ARCHITECTURAL DRAWING

MASTERCLASS

ARCHITECTURAL DRAWING

MASTERCLASS

Graphic techniques of the world's leading architects

TOM PORTER

CHARLES SCRIBNER'S SONS New York

MAXWELL MACMILLAN CANADA Toronto
MAXWELL MACMILLAN INTERNATIONAL New York Oxford Singapore Sydney

Dedicated to the memory of Roger Ferri

First published in 1993
in Great Britain by Cassell Publishing, London.

Charles Scribner's Sons
Macmillan Publishing Company
866 Third Avenue
New York, NY 10022

Maxwell Macmillan Canada, Inc.
1200 Eglinton Avenue East
Suite 200
Don Mills, Ontario M3C 3N1

Macmillan Publishing Company is part of the Maxwell
Communication Group of Companies.

Library of Congress Cataloging-in-Publication Data

Porter, Tom
Architectural drawing masterclass: graphic techniques of the
world's leading architects / Tom Porter.
p. cm.
ISBN 0-684-19521-6
1. Architectural drawing — Technique.
NA2708.P68 1993
720' .28'4--dc20
93-13558 CIP

Created by Amazon Publishing Limited, London
Design: Cooper Wilson Design
Editors: Joanna Bradshaw, Peter Moloney

Macmillan books are available at special discounts for bulk pur-
chases for sales promotions, premiums, fund-raising, or educa-
tional use. For details, contact:
Special Sales Director
Macmillan Publishing Company
866 Third Avenue
New York, NY 10022

10 9 8 7 6 5 4 3 2 1

Printed in Singapore

Contents

The act of drawing embodies a kind of magic: the ability through image-making to shape future events and take command of one's destiny. This association of graphics with a supernatural power began in the prehistoric caves, when a skill in creating recognizable pictures of animals was thought to confer a greater hope of success in the hunt for food. Thereby, drawing became an important talisman of survival. Meanwhile, above ground in that ancient society, the person who could create a straight line was also seen to have extraordinary powers. This person was, in effect, the first 'environmental draughtsperson' who, when aligning two wooden staves with the eye, could determine a dead straight line in the wilderness. When marked with stones or notches on hillsides, the line became an important track that not only guided routes to salt and flint sources, but also provided the initial 'template' for the later establishment of settlements and road systems.

Preface

According to Alfred Watkin, author of a work on ley lines entitled *The Old Straight Track*, the prehistoric stave and the magical properties associated with it became the precursor to the 'magic wand', its user assuming the status of magician. It can also be seen as the ancestor of the drawing instrument and, if we move rapidly forward through time, the wand will also perform other wonders. For instance, when pointed and dipped in pigment, it becomes a pen; when filled with graphite, it becomes a pencil; when fitted at one end with a tuft of animal hair, it becomes a brush; and when hollowed through to have pigment blown down it, it becomes an airbrush.

In the hands of architects today, these modern versions of the magic wand perform remarkable feats. Their marks give shape to our dreams of architecture. As premonitions of future events, architectural drawings hold the power to fashion a world of habitable form and space that previously existed only in the space of the architect's mind.

This book presents the architectural drawings of more than forty internationally renowned designers and explains the media and graphic techniques used in their achievement. It also explores the relationship – in many cases, a close one – between the spirit of individual design approaches and the types of graphics that have been adopted for their pictorial representation. The majority of drawings illustrated were made by the architects themselves and are intended by their authors as presentation drawings, that is, as images for public consumption – by a prospective client, a competition judge, for exhibition or for publication in the architectural media.

Introduction

The contents range from pencil and pen techniques to computer graphics. The chosen images include some that have been achieved deliberately and painstakingly and others that have been produced quickly, often using unusual techniques that give the spontaneity and immediacy of a sketch.

All the drawings testify to the fact that, even in our advanced technological age, the ancient art of drawing remains central to the creation of architecture and to the communication of architectural ideas. Indeed, drawing still encompasses the full gamut of environmental design, from genesis of idea, through its evolution, to its graphic preview before construction. But architectural drawing also serves other functions. For example, included here are some reflective drawings made *after* the realization of a building, and others that depict a speculative vision of an architecture of the imagination. Although many architectural drawings have, in recent years, been bought and sold on the international art market, this new-found status is shunned by the architects represented in this book. For them, the architectural drawing has one function. No matter how stunning its technique or elaborate its image, it exists as a means to an end. Architectural drawing is simply a tool for design and communication.

Cesar Pelli

Cesar Pelli left his native Argentina in 1952 and, after receiving a master's degree from the University of Illinois in Urbana, joined the offices of Eero Saarinen and Associates in New Haven, Connecticut. A decade later, after Saarinen's death, Pelli left the firm and went on to take up executive roles in two large corporate practices before being appointed Dean of the School of Architecture at Yale in 1976. A year later he founded Pelli & Associates in New Haven, and his work ever since has been both ambitious in scale and international in scope.

Pelli has provided urban landmarks for many of the world's largest cities, including the US Embassy in Tokyo, the World Financial Center in New York and the Canary Wharf Tower in London's Docklands. The Pelli building that has most penetrated the public consciousness though, is the Pacific Design Center in Los Angeles. It is a huge and elegant shed-like construction, a seven-storey building clad in ultramarine vitreous enamel and popularly known as the 'Blue Whale'.

Pelli began designing his highly regarded monumental tower projects in 1979, when he received a flood of commissions for high-rise buildings. It is from these projects that his best known and most widely published drawings have emerged. One such drawing – an uninhibited and exploratory sketch for the Corporate Headquarters Tower in Pittsburgh – serves as a representative example of his distinctive and influential graphic work. One of a series of investigative drawings and sketches it is freely worked, using the waxy Stabilo pencil to produce a purely representational image.

Pelli's soft but vigorous drawing style often examines the impact of light, shade and shadow on prismatic form. His technique is reminiscent of the dramatic charcoal drawings of skyscraper projects produced by Hugh Ferriss in the 1920s and 1930s. Pelli's technique was learned from Jay Barr, a partner in Eero Saarinen's office. Barr's technique, in turn, was based on that used earlier by Saarinen for the rendition of his Chicago Tribune Competition submission. Saarinen, coincidentally, was a contemporary of Ferriss's.

Cesar Pelli himself describes his drawing technique as '...a particularly appropriate representation of my own architecture. It is primarily an expression of surface and volume as contrasted to other kinds of drawings that represent lines. We use the same drawing technique for plans, elevations and perspectives. Everybody in our firm can now use it. Because we now use it for every purpose, it becomes more adaptable every day. It is now part of the personality of our firm and our work.'

CORPORATE HEADQUARTERS BUILDING,

Pittsburgh, Pennsylvania, Perspective

Pencil Drawing, 7.5 × 15cm (3 × 6in)

A Stabilo wax pencil and a lightly-textured paper are used for this distinctive drawing technique. The greasy graphite from the pencil picks out the grain of the paper's surface, creating an interesting texture.

The outline of the building, with its stepped setbacks and faceted mass, is drawn first. Next, the rendering is applied, using vigorous diagonal strokes. Each stroke is layered on to the previous one to build up the density of tonal value and to control its tonal structure. The background sky area, the darkest, is achieved by using heavy pressure during rendering and acts as a strong contrast to the silhouette of the building itself.

The use of tonal contrast is an important feature of Pelli's masterly drawings; it is also one that strongly affects the compositional impact of his graphics, since the shading technique can be used to emphasize the sculptural quality of a building in different ways. The expression of light and shade on a building can so strongly affect the finished image that Pelli and his team often decide which effect is most suitable for a drawing by experimenting first with thumbnail sketches before doing the final rendering.

WORLD FINANCIAL CENTER,

New York, Perspective

Stabilo Pencil Drawing, 61 × 45.5cm (24 × 18in)

Pelli enjoys using his diagonal rendering technique for rough sketches as well as for finished presentation drawings. The diagonal discipline is versatile and allows several designers to work on the same drawing, which is a positive advantage in many large architects' offices.

A fine example of Pelli's diagonal rendering is found in his widely published perspective drawing for the World Financial Center complex in New York (see page 12). In it we see a more refined version of his distinctive arcing pencil strokes. These strokes are soft and controlled, their tight structuring and layered application combining to achieve a perfect example of tonal and

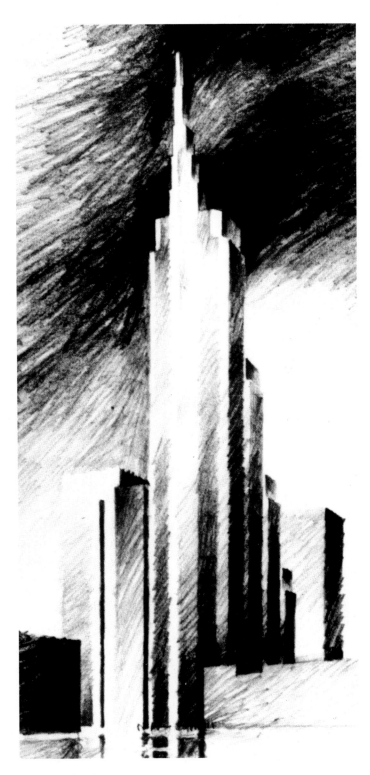

CORPORATE HEADQUARTERS BUILDING, Pittsburgh

WORLD FINANCIAL CENTER, New York

compositional contrast. The success of this composition, however, lies in Pelli's handling both of direct and indirect light.

The glowing effect achieved in this drawing is the result of a masterly rendering of shaded and shadowed planes, making full use of simulated reflected light. It is this effect which lends Pelli's drawings such a sense of richness. Reflected light is shown as appearing in shaded planes and, in turn, as being redeflected into the body of shades cast on to other planes.

As well as achieving a subtle differentiation between pencil strokes depicting sky and those representing the architectural form, Pelli's drawing technique also conveys a convincing illusion of the foreground water reflection. This is created by rendering the inverted impression of his waterfront buildings in a consistently dark, finely grained and closely related tonal system. Generally speaking, reflections in water and glass should always be among the darkest elements in a drawing, since this is how they are perceived in reality.

KANSAI INTERNATIONAL AIRPORT, Perspective

Pastel and Coloured Pencil, 101.5 x 30.5cm (40 x 12in)

This competition drawing was produced, using the Pelli office style, by Jon Pickard. To determine the best possible composition for the drawing (see pages 14 and 15), photographs were taken of the scale model of the terminal building. Three views were considered: a high aerial vantage point (that is, as seen from an aeroplane), a low frontal approach view of its airside elevation, and another eye-level view looking obliquely along its longitudinal axis. The second view was selected, since it conveyed the best possible visual information after being fed on to an Intergraph computer. The image was then generated as a wireframe perspective drawing to serve as an underlay guide for the subsequent rendering.

The next stage in the process involves the development of a tonal structure for the colour composition of the drawing. Tonal relationships predetermine the visual dynamic of any colour composition.

A sheet of 1000H tracing paper is used as an overlay for the computer-generated drawing of the terminal building. Since the initial stage of rendering involves the application of a pastel dust 'wash' in the sky area, the outline of the building is also protected with a trace-cut Frisk mask.

The pastel dust is made by scraping the sides of three sticks of pastel with a scalpel blade, well away from the artwork, to produce three distinct deposits of pigment. Each colour is sprinkled individually on to the sides and centre of the exposed sky area. In this case, the colours are blue-violet on the left, red in the centre and yellow to the right. The deposits of pastel dust are smoothed down with tissue and/or a 'stump' (a tightly twisted wad of paper),

1

2

3

WORLD FINANCIAL CENTER

(Details above taken from the drawing opposite)

1 The diagonal pencil shading technique brings a pervading sense of order to the drawing. Its systematic use can describe a wide range of surfaces, textures and effects.

2 The continuous compositional arrangement of silhouetting dark edges against light backgrounds, and vice-versa, produces a visually exciting pattern of contrast that functions to animate the drawing and heighten its clarity of information.

3 By allowing shadowed planes to increase in lightness as they move away from their edge, a strong impression of reflected light is conveyed.

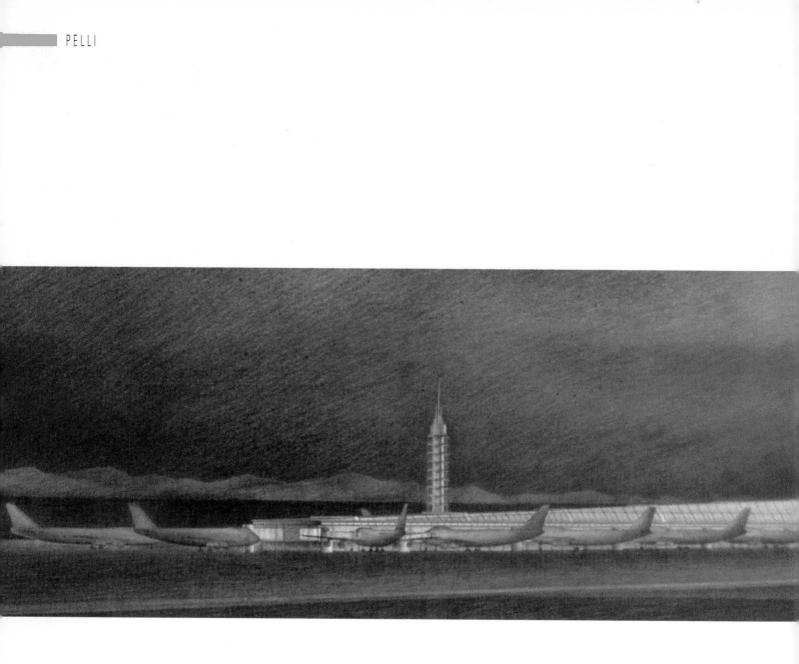

to create the spectral effect of a tricoloured wash. Excess dust is gently brushed away and a fixative applied.

Next, five basic coloured-pencil hues, blue-violet, ultramarine, yellow-orange, orange and crimson lake, are used selectively on top of the pastel base wash. The combined media generate a stronger colour saturation and textural effect than would pastel alone.

Once the Frisk mask is removed from the outline of the building, rendering is continued in coloured pencil on the terminal building, control tower and foreground plane. Finally, when the colour composition is established and the desired tonal value and colour balance achieved, black pencil is introduced. Black is never used in the developmental stages of colour rendering because it has a dulling effect on other colours. Used at the end of the process, it emphasizes edges and sharpens the image.

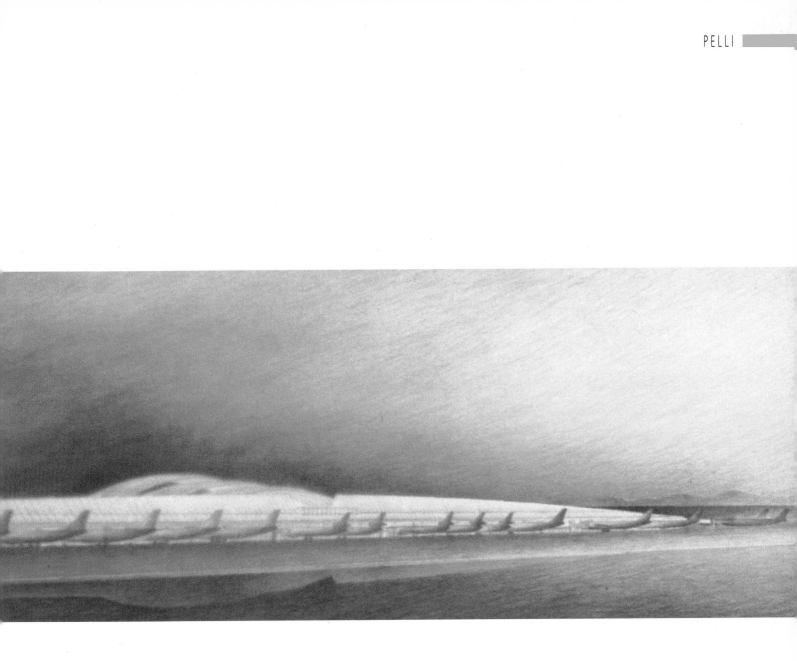

KANSAI INTERNATIONAL AIRPORT

The computer-generated image of the outline of the terminal building is protected by Frisk film before the application of a pastel rendering of the surrounding area begins. Three separate deposits of pastel dust in blue, red and yellow are applied individually to the background, then blended in, using a stump made from a twisted wad of paper.

After the pastel dust wash has been stabilized with fixative, the tricolour rendering is worked over in purple, blue, orange and red coloured pencils. Each colour is applied to intensify and blend with its equivalent colour in the pastel wash.

After the Frisk mask has been carefully removed, the terminal building is rendered in coloured pencil. The final image makes the airport building glow in an atmospheric sunset.

Following his sensational début in the early 1960s, Shin Takamatsu quickly achieved international recognition. His work, like that of Tadao Ando, Arata Isozaki and Kisho Kurokawa, was part of a new wave of innovative architectural ideas that came out of Japan during the decade. Takamatsu first attracted

Shin Takamatsu

attention after the completion of a series of buildings dotted around the ancient former Japanese capital of Kyoto. These buildings, with names such as Exe, Pharoah and Ark, have transformed our normal perception of architecture. Designed fortress-like to withstand the rigours of the modern city, they are produced apparently by means of a 'super technology'. They display no signs of traditionally crafted finishes, and offer a straightforward machine metaphor of pistons in their cylinders, cranks and rods. Such designs question the historical appearance of buildings and transport us into a surrealistic world.

Takamatsu's later work is on a larger scale. His more recently realized buildings include a restaurant-shop, Solaris, in Hyogo, and Ecole, a music school/recording studio in Kyoto.

An architecture such as this demands a visualization technique that reflects the immaculate quality of its form and finish. Takamatsu's graphics are produced by traditional rendering techniques using the graphite pencil and the coloured pencil, but these media are employed in a particular way to provide a highly realistic preview of his designs.

ARK Building, Kyoto

ARK Building, Kyoto, Elevation
Graphite on Kent Paper, 79 x 109.5cm (31 x 43in)

This superb elevation drawing (left) is typical of Takamatsu's highly realistic rendering style. It is not executed to a conventional architectural scale but, like most of his orthographics, is drawn to a scale dictated by his 79 x 109.5cm (31 x 43in) drawing paper format.

The graphite shading is worked over an exhaustive outline drawing drafted-with a 4H-grade pencil to describe all the elements of the façade. Then, a smooth overall wash of graphite is carefully delivered from the same pencil, using a tight structuring of 45-degree lines which are then blended slightly with the tip of the finger.

The next stage enlists two more graphite grades, 3H and 2H, for a further layering of the initial graphite wash; this time to differentiate between the tone and the surface qualities of materials seen in the larger areas of the elevation. Shade and shadow are then defined, using subtle progressions of darkness on the polished forms. This phase is completed when the edges of shadows are meticulously defined as the very darkest areas of graphite.

ARK BUILDING, Kyoto, Detail

At this stage, Takamatsu uses a pointed eraser to begin another step in the modelling of tone in the drawing. He uses the eraser as a drawing instrument, i.e., as a 'white pencil', to etch in fine lines, to give an aura of light to overlapping edges, to introduce highlights and, generally, to clarify the tonal pattern of the image. After this, final touches from his 4H pencil complete the drawing.

KIRIN PLAZA BUILDING, Shinsaibashi, Osaka, Floor Plans
Coloured Pencil and Graphite, 79 x 109.5cm (31 x 43in)

The following technique, typical of Takamatsu's drawing style, involves the use of a technical pen, a coloured pencil and a range of 4H, 3H and 2H pencils to create an almost photographic impression, looking down into a sunlit volume of space as defined by the plan. The outline and extent of the floor plan and its abstract cutting plane are first simply delineated, with a fine-line technical pen applied to a good-quality cartridge paper.

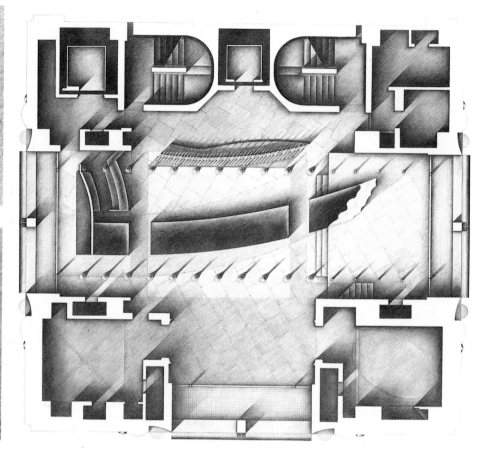

KIRIN PLAZA BUILDING, Details

KIRIN PLAZA BUILDING, Osaka, Third-Floor Plan

1 The interior floor area is coloured with a smoothly applied 'wash' using a coloured pencil. The direction of its strokes corresponds to the direction of the light.

2 The 45-degree edges of cast shadows are lightly ruled using graphite. The shadow treatment is applied as a smooth graphite shading, working diagonally from the shadow's casting edge and allowing its extremity to fade.

The next stage involves the application of an overall 45-degree coloured pencil wash over the floor area as demarcated on the plan. Takamatsu uses Castell coloured pencils for this stage and, so as not to cause distraction in the finished artwork, keeps to a muted or neutral hue. However, what is most important of all at this stage is that the coloured pencil wash be laid down in a technically exact manner. The wash is applied gently in a tight layering of fine strokes which are deposited to produce an even tone, following the assumed direction of sunlight.

Two points should be noted about the application of the wash. First, it is important that an even deposit of colour is maintained across the entire area contained by the plan and that a crisp edge is achieved around the inside of walls. Second, as the wash represents a tonal step between the white drawing paper seen in the sectional slice and the dark shadow treatment, importance is given to creating a mid-tone. Within this mid-tone, Takamatsu gradually introduces subtle variations of colour strength in order to differentiate between the individual modules of floorscape areas, such as those seen in the third-floor plan (see above).

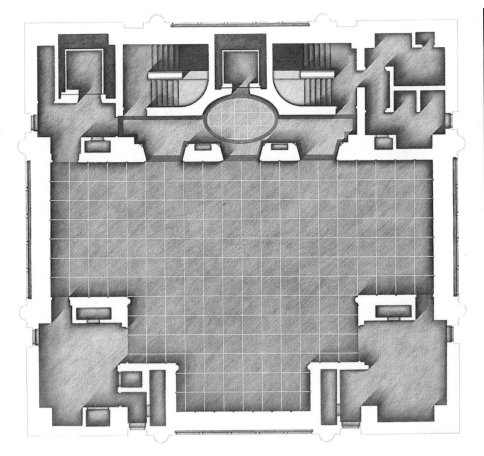

KIRIN PLAZA BUILDING, Fourth-Floor Plan

3

4

KIRIN PLAZA BUILDING, Details

Next, the shadow pattern is introduced into the plan by means of a 2H-grade pencil, used at the same 45-degree angle as that of the initial coloured pencil wash. First, the outline edges of shadows cast from the corners of walls and apertures, such as doors and windows, are lightly ruled in, at 45-degree angles and to a length that corresponds to the height of the sectional cut. To avoid a common error, the edges are projected outwards from the outer corner of wall openings rather than from the inner corner.

The three-dimensional illusion associated with Takamatsu's technique results from a darker shadow that emphasizes the casting plane of the wall, fading as it approaches its extremity. Therefore, the darkest portion of the shadow is established first, then, using controlled strokes in lighter grade pencils, its 45-degree directional progression is rendered, from dark to light tones.

A most important feature of Takamatsu's plans is his insertion of a narrow 'aura' of tone along all the wall planes receiving light, and a narrow line of reflected light along edges of forms furthest from the light source. It is this tonal emphasis that causes the sectional slice of the plan, and the objects it contains, to appear as occupying a plane forward of the picture plane.

3 Takamatsu's depth illusion is completed by the addition of a narrow 'aura' of tone along the light-receiving walls of the plan. This subtle feature emphasizes a contrast between the space of the plan and its containing walls.

4 A variation of Takamatsu's technique is the initial scoring of selected parts of the floorscape with the blunt side of a scalpel blade against a straightedge. When shaded with the ensuing layers of coloured pencil, the score lines reveal the gridded floorscape effect as a negative pattern.

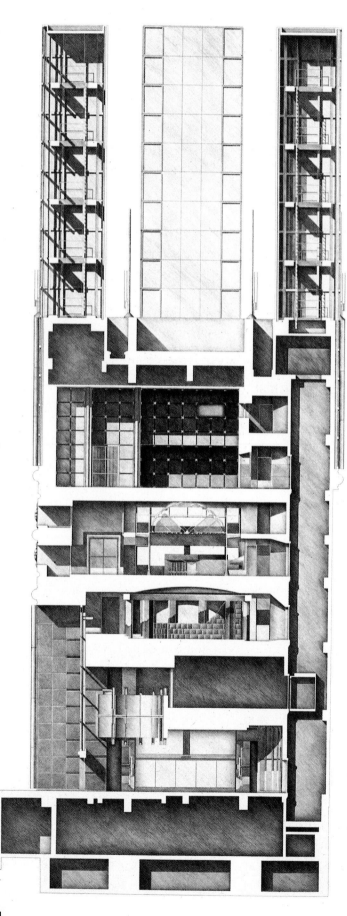

KIRIN PLAZA BUILDING, Shinsaibashi, Osaka, Section
Coloured Pencil on Kent Paper, 79 x 109.5cm (31 x 43in)

Takamatsu's rendering principles are also employed in his section drawings – the sectional view simply functioning as a vertical plan. His powerful illusions of depth are achieved by means of graphic features.

For instance, to create the strong impression of looking into the spaces revealed by the sectional cut, all the sectioned edges of exposed rooms (except where light directly enters the building) are slightly over-emphasized in tone, even those edges of planes that face directly into sunlight. Also, a greater depth is simulated when darker tones describe deeper recesses of space, and vice versa. In Takamatsu's drawings, however, an extreme depth of tone is never rendered as a flat, solid black; the darkness of his tones allows the eye to read his pencil strokes, creating an effect that implies an atmospheric darkness which, in turn, suggests distance.

A further dimension to Takamatsu's drawings is his use of shading to describe different qualities of surface and material. It is interesting, for example, to compare the grain of his technique for the wall cladding with that used for the basement and, again, with that used for the lift shaft. These subtle differences in quality result from mixing together different graphite grades while retaining a sharp point on the pencil. They also stem from his adoption of different touches on the paper during rendering. These range from tightly controlled, shorter parallel graphite strokes to longer, looser strokes, but they never waver from the relentless diagonal discipline of their application. A meticulously clean, sharp edge is also maintained throughout the drawing format – faded edges occuring only on the cylindrical planes seen in the main entrance area.

KIRIN PLAZA BUILDING

George Ranalli

George Ranalli is a native New Yorker who studied at the Pratt Institute and the Graduate School of Design at Harvard University. Since 1976 he has been Associate Professor of Architectural Design at Yale University where, in 1988-89, he occupied the William Henry Bishop Chaired Professorship. Ranalli's realized work includes the First of August dress shop in New York and the Callendar School renovation in Newport, Rhode Island. His design work has been exhibited all over the world, most notably at New York's Cooper-Hewitt Museum and the Metropolitan Museum of Art, the Centre Pompidou in Paris, the Deutsches Architekturmuseum in Frankfurt and at the XVII Milan Triennale. A monograph entitled *George Ranalli: Buildings and Projects* was published in 1988 by Princeton Architectural Press. His work appears regularly in such journals as *Domus*, *A+U*, *Progressive Architecture* and *Architecture d'Aujourd'hui*.

One area of work for which Ranalli is well known is his New York loft conversions. These exist as an architecture within an architecture, in which the public and private functions of everyday living are celebrated within a seemingly self-contained world. This 'Ranallian world' is created from the assembly of clearly defined geometric volumes which, rather than resulting from the fragmentation of a whole form, are constructed as an adjunct to an overall spatial complex. Essentially, this is an architecture of space and spatial hierarchy. On the one hand, it can be magnified by Ranalli into the huge scale of his tower projects, such as that for Times Square or, on the other hand, it can be scaled down to tactile body architecture, represented by small objects such as a table, chair or door handle.

This spatial language is defined by an innovative use of materials and connections to provide immaculate planes which are characteristically notched, perforated or crenellated to articulate the movement of light. Indeed, it is the impact of light on the precision of these planes and their incisions that is reflected in Ranalli's unique graphic style. For instance, his drawings exist more as two-dimensional graphite sculptures that 'carve' out the orthographic space of plan, section and projection drawing in response to the flow of light. Albeit an illusion, this strong visualization of architectural space and volume relies upon a highly controlled rendering style, using a right-handed 45-degree application of line. This discipline, common in architectural design, is transformed by Ranalli into a highly personal 'signature', one which makes his graphics stand out from those of others.

RANALLI STUDIO

Ranalli's technique derives from the laying down of sequences of diagonal graphite strokes which, worked across the entire format of a drawing, are gradually built up, layer by layer, to form a range of intensities. Obviously the gradual layering of tonal value is governed by a clear mental picture of the factors affecting the composition, such as direction and intensity of the prevailing light source. Furthermore, variations in the application of this technique

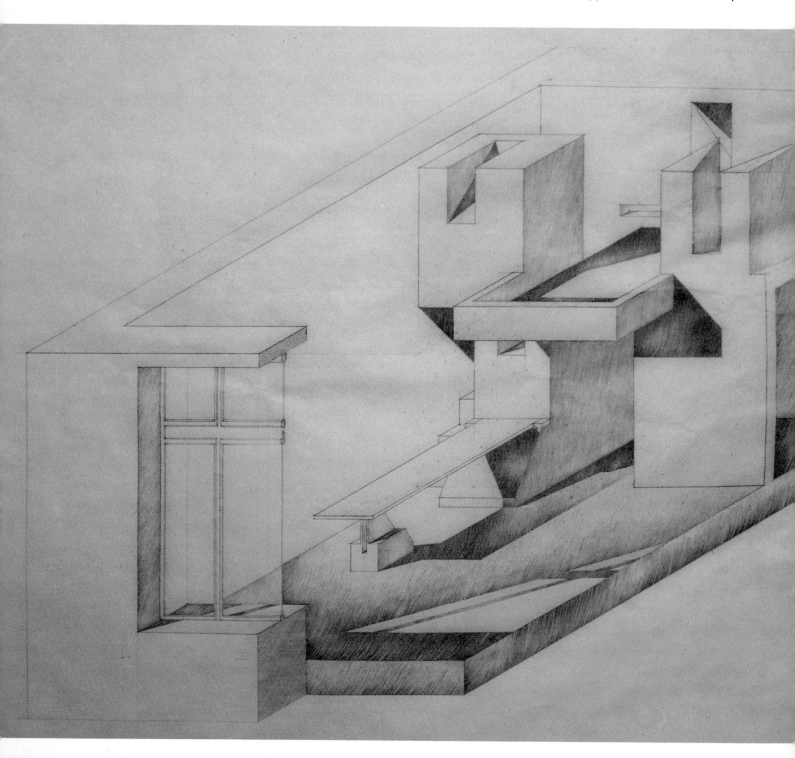

can provide a remarkable range of unpredictable perceptual qualities, such as the subtle incidence of light variation, transparency and reflection.

Ranalli describes the role of graphics in his design process as follows: 'All my drawings are used to expand on ideas about space, form and material. Each decision about the projection system, light source, shade and shadow is made to enhance an idea about the architecture. Many drawings are completed at the time of the design of the project; some drawings are completed at a later stage, when reflection upon the project or the construction has revealed an insight. In this the drawing becomes the recording of thoughts about the architecture. With this in mind, the drawing is more than technique. It is a construction itself, with decisions being made to fulfill its own design. Ideas about technique are related to the spatial ideas embodied in the architecture. Some reference to materials is also essential. Hopefully, the drawings can remain in a place between idea and reality. It is not so much about accurate rendering as it is about an impression or atmosphere about a space or building. The drawings contain their own space and the drawings are a key to the larger spatial, formal and material idea.'

RANALLI STUDIO, Elevation Oblique Projection
Graphite and Coloured Pencil, 71 x 56cm (28 x 22in)

First, a series of exploratory thumbnail sketches is made to identify the spatial idea for the drawing. These preliminary sketches, usually drawn on paper 12.5 x 17.5cm (5 x 7in) or 20 x 25cm (8 x 10in) in size, using a very soft Eagle or Berol 314 pencil, explore and assess compositional variation, both in the angle of the orthographic projection and in its pattern of shade and shadow. Once the appropriate composition is identified, an enlarged outline drawing is made on opaque paper in light pencil and is completed with shade and shadow construction lines. Usually, Ranalli will work on a sheet of 100 per cent rag vellum – a paper selected for its receptivity to the pencil. Alternatively, he will sometimes use Fabriano or d'Arches paper.

RANALLI STUDIO

Ranalli's graphite rendering is deftly built up in progressive layers – each being applied freehand in the direction of the light and retaining the character of individual strokes. Ranalli sees the edges of planes and forms in shade or shadow as important boundary lines in the drawing, so these are emphasized.

In the colour-rendered area, Ranalli superimposes a slightly open, coloured pencil 'wash' of one colour over a seamless 'wash' of another colour. The resulting colour combination 'mixes on the eye'.

CHICAGO TRIBUNE TOWER COMPETITION

(Main picture right, detail above)

The tower is rendered in a combination of graphite and coloured pencils and chalks in a subtle colour range, including three blues.

Using masking film, a wash of airbrush grey is applied to the base of the tower and, in order to enhance the pencil and chalk rendering, also to smaller areas.

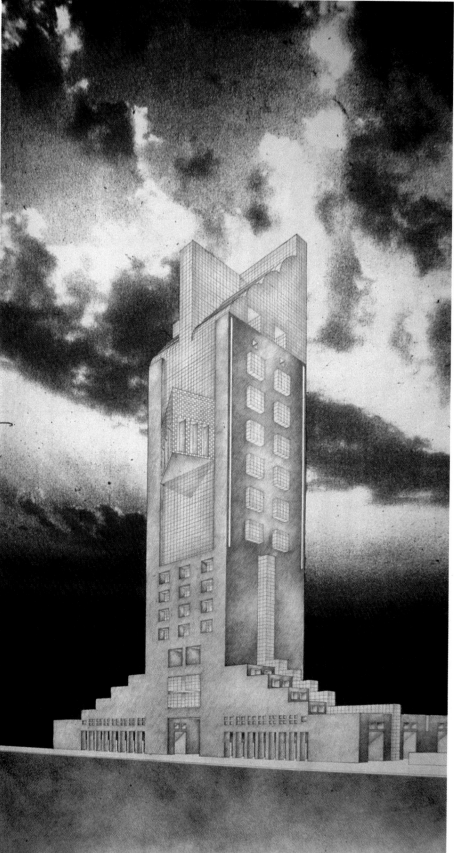

During the rendering phase, all the layers of graphite and coloured pencil are applied freehand, i.e., without the aid of tape, mask or straightedge. Various graphite pencils are used, but usually they are in the 2H to 4H-grade range. When a more intense black is required, Ranalli will use a Derwent Ivory Black or a Stabilo Black pencil and mix these with the other graphite grades.

The shadowed planes, which represent the darkest areas in the image, are usually rendered first, working in from all sides of the drawing. These are followed by the shaded areas of the drawing, working gradually from its darkest to its lightest tonal area. Once established, this preliminary layer of graphite is then constantly worked over to build up slowly the required intensity of tonal relationship; constant assessment of the developing rendering helps to judge when this process should cease.

Although graphite tone is usually applied first, Ranalli will quickly introduce colour and then switch successively between techniques of application. For instance, while graphite is applied in Ranalli's distinctively hatched strokes, deposits of coloured pencil are applied in a smooth, even 'film'. Ranalli's experience tells him that strokes of colour do not reproduce as clearly as those in graphite.

In this drawing, two coloured pencils are used: a True Blue and a Light Blue Prismacolor, one worked directly over the other. This layering of colour provides a visual field in which, when viewed closely, the individual hues can be detected. When seen from a normal viewing distance, however, the hues fuse into a single colour.

CHICAGO TRIBUNE TOWER COMPETITION/Late Entries, Perspective
Coloured Pencil, Chalk, Airbrush and Photomontage on Sepia-Print Paper,
76 x 152.5cm (30 x 60in)

This image took as its starting point a photograph of a striking sunset. The photograph, showing a strong spatial movement of clouds above an expansive foreground landscape, was shot deliberately with a clear mental picture of its compositional function and its suitability as a backdrop to the tower design clearly in mind. The photograph was then processed as a 38 x 76cm (15 x 30in) positive black-and-white print.

Next, a perspective outline drawing of the tower design was made in pencil on vellum and then trace-cut around its silhouette before being glued into position on the photographic print, using rubber cement. The resultant montage of photograph and drawing was then rephotographed to provide a second-stage print. The negative was this time printed in monochrome on to Mylar to an enlarged size of 76 x 152.5cm (30 x 60in). Using the standard

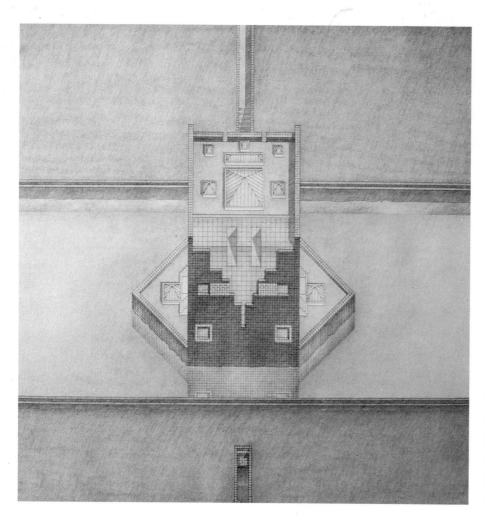

dyeline process, the Mylar print was then reproduced for a third time in the form of a same-size sepia-tone photographic print.

At this stage Ranalli has achieved a line drawing of the tower against a sepia-toned sky that has been 'rendered' by the dyeline print process. The rendering of the tower uses three grades of black Derwent pencil (2H, 3H and 4H), together with Black Prismacolour and Derwent Ivory Black. The glazing is worked in a range of blues including Prismacolor True Blue and Light Blue and Derwent Kingfisher Blue – occasionally softened with White Prismacolour. The rendering stage is completed with a grey airbrush wash applied to the ground plane. Airbrushing is also used in other portions of the drawing to emphasize proportion in small areas and to enhance the colours.

FREHLEY HOUSE

FREHLEY HOUSE, Elevation Oblique
Coloured Pencil on Heavyweight Drawing Paper, 90 x 90cm (36 x 36in)

This drawing is a good example of Ranalli's graphite rendering technique adapted for coloured pencils. Its limpid quality stems from the application of many, many layers of colour, and mixtures of colour, each layer being applied in his distinctive and softly arcing diagonal rendering strokes. Confined to a cool scheme of blues and greens relieved with bands of brown, the colours are deployed clearly to differentiate landscape from water and areas of opacity or transparency in the building. His deliberate decision to draw the building design as an oblique elevation responds to his idea of '. . . combining the conceptual and the perceptual drawing'. Its dead-centre placement in the square format results from his wish to '. . . combine the elements of the architecture with those of the landscape, as well as interconnect the idea of the drawing to the idea of the building'. The drawing is then represented with all the phenomena of shade, shadow and light.

Alan Phillips

Alan Phillips graduated from the Brighton School of Architecture in 1972 and established his Brighton- and London-based private practice in 1973. As well as designing widely published work, Phillips is a teacher, author and journalist and has lectured extensively on the philosophy of aesthetics in Britain and America. His realized assignments range from industrial and commercial projects in Britain to private residences in other parts of Europe and America. He is also known for his interior schemes for the Trattoria Capri, a restaurant complex in Plymouth, Laing's nightclub in Brighton and his prize-winning conversion of London's old Diorama Building in Regent's Park into an arts centre.

Phillips's much-exhibited drawings reflect his firm conviction that drawing is the only means of making tangible the architect's imagination. He says: 'Drawing is the interface between that which is imagined and that which is built. There is no substitute. Consequently, the architect's imagination is limited by his or her inability to draw.'

His drawings are used both to preview a design idea and also to examine its meaning once a building has been constructed. Indeed, on the basis that the design process is unending, Phillips has, for several years, been steadily documenting many of his realized schemes retrospectively in a series of large drawings.

Phillips's retrospective drawings are produced in the same way as colour separations. But for Phillips the separation is not one of different colours, but one of different drawing types and different drawing media. Worked on individual sheets of polyester film, the 'separations' also represent different drawing activities. For example, two or three separations focus on different design issues such as the object of the design, the subject of the design and its context. The final impression of this layered activity is finished when the two or three graphic elements are brought together photographically and combined as a single printed image.

Phillips describes this technique as a means of exploring and communicating the various design issues in a clear manner – each issue employing a different medium, such as photocollage, ink or graphite. His technique is best explained by one of his 'three-separation' drawings, involving the assembly of quite different drawing attitudes in one composite image. The drawing depicts Phillips's design for a column supporting a staircase in the London home of his client, Dr J. Goldman, a leading haematologist. Dedicated to the Goddess Minerva, the column symbolizes wisdom, science, and religion – concepts that form the core of Dr Goldman's beliefs.

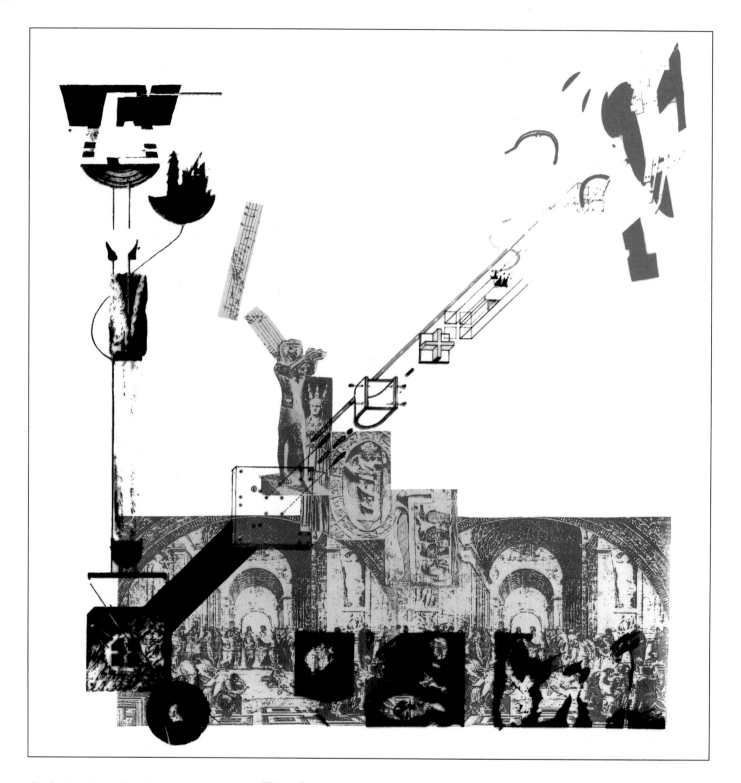

The final, combined effect of the three separate drawings is not fully realized until they are reproduced as a composite image. Quite apart from the printed interaction of the three drawings, colour is introduced to the third 'separation' only at the time of printing, its precise hue then being communicated to the printer by means of a Pantone colour reference swatch.

THE COLUMN MINERVA, London, Xerox Collage
Graphite and Ink on Polyester Film, 84 x 84cm (33¹/₂ x 33¹/₂in)

Like many of his drawings, this is a square format – a shape that Phillips regards as 'democratic', in that it does not exert directional influence on the ensuing composition. The composition itself was thoroughly preplanned prior to the production of the separations – its constituent elements being first outlined carefully on 'bumwad' (yellow tracing paper) to act as an underlay guide.

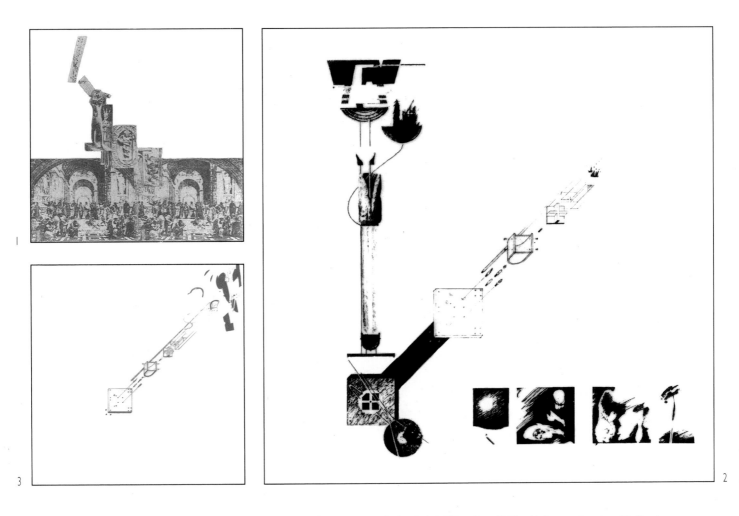

COLUMN MINERVA, Details

These are the three drawings, or 'separations', produced individually by Phillips. Each is created using a tracing-paper master as a guide, and each involves quite different media and drawing techniques. Furthermore, each image pursues quite different ends, such as (a) context, (b) object and its origins, and (c) its assembly and construction.

1 The first separation consists of a series of photographic images which, after some reduction and enlargement on the photocopier, are assembled to form an abstract collage representing the theoretical context of the design. The elements of the collage are then photocopied on to Transtext (a transparent, adhesive-backed acetate) and individually mounted on the polyester film.

2 The second separation, worked entirely in 2H-grade pencil on polyester film, focuses on the design as object (the 1:50 elevation) and the design as subject (the four inset boxes). Using the delineated under-drawing as a guide, both the elevation and inset boxes use no outlines but are traced as flat and precise areas of shaded tone – a useful technique because it comes close to the way that we perceive objects in space. Furthermore the pencil, by affording an enormous tonal range (extended in this case by the receptivity of the plastic film) plus a remarkable range of line quality, is considered by Phillips to be a most 'forgiving' drawing instrument. The versatility of the medium is also extended by his use both of the point and the side of the graphite – Phillips removes the lead from the barrel in order to drag it flat on its side, to create the wisps of flame at the head of the column.

3 The third separation, traced in Rotring pen on a third sheet of polyester film, is worked entirely with 0.15mm stylus. Having quite a different function from the first separation, it focuses on what Phillips calls the 'tectonics' of the design, i.e., the assembly and construction of the column.

In this case, Phillips exploits the abstraction of orthographics by mixing isometric, axonometric and perspective projections in one multi-view image. These projections may be stretched, warped and exploded graphically – a distortion he uses for maximum communication of constructional information and, of course, for maximum visual impact.

The process is completed after the three separations have been photographed to produce two monochrome negatives and a colour transparency. Using registration marks, the separations are then overprinted.

Norman Foster qualified in both architecture and city planning at Manchester University in 1961, and was awarded a Henry Fellowship to study at Yale, where he received a master's degree in Architecture. After travelling and working in the United States, he returned to London in 1963 and four years later

Sir Norman Foster

he founded Foster Associates (now Sir Norman Foster and Partners). Since its formation, the practice has established a major international reputation based on a formidable series of completed projects. These include the Sainsbury Centre for Visual Arts at the University of East Anglia, Norwich and its recent addition, the Crescent Wing; the Head Office for Willis Faber Dumas at Ipswich; a Technical Park for IBM at Greenford; and the Renault Parts Distribution Centre at Swindon. More recently, Sir Norman Foster and Partners's celebrated Headquarters for the Hong Kong and Shanghai Banking Corporation was opened in 1986 in Hong Kong, and his terminal for London's third airport at Stansted in 1991. Other notable Foster buildings are the ITN Headquarters, London; the Century Tower, Tokyo; the Sackler Galleries, Royal Academy of Arts, London; and the Telecommunications Tower in Barcelona.

Foster is the recipient of over 60 major honours and commendations and in 1983 he received the RIBA Royal Gold Medal for Architecture. He was knighted in the Queen's Birthday Honours list of 1990.

Having established itself as a leading company in the field of new production technology, serving cultural, contextual and human needs, Foster's practice makes use of drawing as just one facet of a wide-ranging design approach. The use of scale models is also an important feature of its design investigations. Ranging from small site models to full-size mock-ups that simulate building components and room spaces, these models reflect Foster's obsession with architectural quality, from the largest features to the smallest details. To house this ambitious operation, Foster's office is part traditional studio and part workshop, with spaces six metres (18 feet) high. Consequently, the prefabrication of full-size prototypes is seen as a valuable form of visualization, further enhanced by computer modelling, which allows a greater speed and depth of three-dimensional exploration.

Sir Norman Foster's drawings, therefore, have to be viewed against this background. For instance, his incisive drawings, worked in technical pen or pencil and rarely rendered, are essentially direct and workmanlike. They include his widely published ink sketches, which range in scale from roughly sketched outlines of an evolving building mass to glimpses into the volumes of interior spaces, and from a scrutiny of body architecture such as handrails and stairs down to a study of smaller architectural details such as component connections.

These drawings portray points in a design journey that provide feedback from the evolution of a complex design scheme; an operation that engages large but close-knit design teams. They also reflect Foster's mental viewing

stance, as his mind's eye travels through the space and scale of an architectural idea; each drawing type, whether it be an elevation or a perspective, responds to the continuous dialogue between concept and mode of expression. In turn, these drawings also demonstrate the two-way cycle of an idea, as it passes between mind and paper. Extended by computer and physical simulation, it is an alternating cycle of events that is only completed when the creative process has been completely exhausted.

Foster's drawings will, occasionally, appear at the presentation design stage. This phase is often signalled by a completely different drawing attitude. It is one that not only entails converting the paper trail of design into a more public and formal rendition of the architectural form, but also its communication to clients and its publication in the architectural press.

INTEGRATION OF STRUCTURE & SERVICES

SACKLER GALLERIES, ROYAL ACADEMY OF ART, London

Sectioned Isometric Projection

Graphite on Detail Paper, 84 × 59.5cm (33 × 23¹/₂in)

With its cutaway section revealing inner spatial workings, the Sackler Galleries projection drawing is one example of Foster's rarely seen presentation graphics. Like his conceptual ink sketches, this drawing is worked in freehand using

HONG KONG AND SHANGHAI BANKING CORPORATION, Concept Sketch

Ink on Tracing Paper

a Pentel clutch pencil loaded with a grade B lead. Unlike the vigorous spontaneity of the sketches, however, this delineation is premeditated, being partly drafted as an overlay with reference to a hardline version of the same drawing. Allowing a freehand ghosting of a technically precise drawing, this technique is much used by designers. It is just this latitude of freedom that allows the line to breathe and assert its personality – a quality that is fully exploited in Norman Foster's drawing.

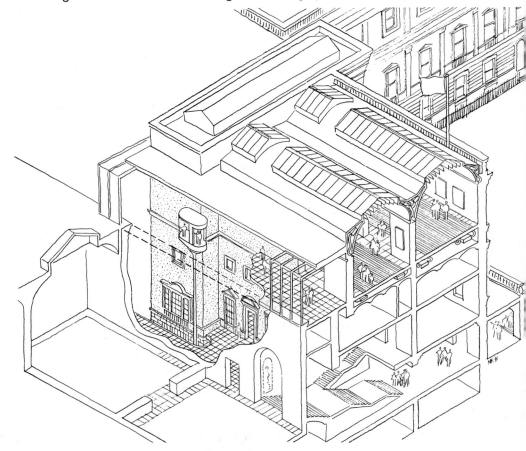

SACKLER GALLERIES, London

Takefumi Aida

Takefumi Aida set up his practice in Tokyo in 1967, a year after completing his master's degree in architecture at Waseda University, Tokyo. In 1971 he received his doctorate degree from the same university.

From 1968 onwards he has created a prodigious output of work, including a stream of award-winning building designs and a visiting lecturer programme that has taken him to design institutions in China, India and North America as well as Japan. He has been invited to participate in many international exhibitions, including the 1985 Venice Biennale, and his work and ideas have enjoyed extensive publication.

Bridging the cultures of East and West, Aida's work divides loosely into three phases. The early work, dating from 1968 with his Artist's House in Kinitachi, questioned the Modernist dictum that form follows function rather than design sensibility, and continued until the construction of his Hotel in Shiobara in 1977.

A second phase saw his fascination with the notion of 'architectural playfulness', a design strategy exemplified by geometric building – block solids, primary colours and random patterning. Approximately eight years in duration and concurrent with the neo-Modernist ideas of the time, this phase was expressed by his string of famous 'Toy Block' houses, sited mainly in Tokyo.

A third transformation occurred at the end of the 1980s, this time a design approach exploring Deconstructivist concepts of a spatial 'fluctuation' and 'disturbance' caused by sequences of layered architectural planes. Aida describes this current stage in his work as one that, through the layering of transparent and semi-transparent walls and screens, simulates a microscopic experience of the way we perceive an urban landscape. For example, he says,

KAJIWARA HOUSE, Kinitachi, Elevation,
Originally Drawn in Pencil, 100 x 73cm (39 1/3 x 28 1/2 in)

'If we look at a cityscape through a telescope lens, buildings appear to overlap and fluctuate – my intention is to produce a similar effect.' Aida's aim is to heighten the effect of space by reducing the degree to which it is defined. He describes the resulting experience as one of 'invisible space', one that does not materialize until the user is conscious of it.

This layering and screening is reflected directly in his elevation drawings. While affording a penetrating view through an entire sequence of vertical planes, however, these function more as x-ray drawings – combining the elevation drawing with the section drawing.

KAZAMA HOUSE, Kinitachi, Elevation (above), Originally Drawn in Pencil, 100 x 73cm (39$^{1}/_{3}$ x 28$^{1}/_{2}$in) Aida's fluctuating line drawings (opposite, above and below) resemble the flickering lines on a black and white television screen, providing penetrating views through the elevational planes. This kind of 'x-ray' vision is a result of being able to see hidden lines which normally would be concealed behind overlapping planes.

TEMPLE SAIONJI, Muryojudo, Tokyo (page 34)

With this drawing (below) Aida wanted to represent architecturally the ambiguous image of 'fluctuation'. The following process controls the 'fluctuations' which occur in elevation and lets the observer perceive the configuration of, and the distance between, each wall simultaneously.

A number is assigned to each wall in plan, then a grid of horizontal lines is used to determine the configuration of each wall. By repeating the same operation for each wall, the drawing forms (in elevation) an invisible organization of walls in space.

TEMPLE SAIONJI, Muryojudo, Tokyo, Elevation

Graphite on Japanese 'Washi' Paper, 100 x 73cm (39^1/$_3$ x 28^1/$_2$in)

All of Aida's *yuragi* (fluctuation) drawings are drawn to fit within a B1 format and therefore do not conform to traditional architectural scale. Aida makes his drawings using a technical pencil loaded with a B-grade lead that delivers a line 0.4mm thick. He wears a pair of soft gloves to avoid smudges. The elevation begins with reference to a plan showing the footprint of walls. Each wall is then assigned a number following a progression from 1 for the wall nearest the viewer, 2 for the next wall, and so on. The elevation of the walls is then projected from the plan – their height being plotted against a regular calibration of lines established to the left-hand side of the drawing.

The drawing itself proceeds with the plotting of each wall in the elevation, using horizontal ruled graphite lines following a numbered sequence. Delineation starts with Line 1 which makes its sweep across the face of the elevation and works down the drawing until it breaks to reveal the silhouette of Wall 1. Next, Line 2 (representing Wall 2) is introduced and, while recording its hidden-line presence behind Wall 1, echoes the combing action of its predecessor until it reveals Line 2. This sweeping linear process of ruled lines is repeated through the entire sequence of walls, each numbered set of lines singling out and disclosing its equivalent wall plane until the format is completely filled with horizontal lines that reveal Aida's 'invisible' organization of walls in space.

The final image is similar to that of a monochrome television picture, i.e., an intense screen of fine horizontal bands which, when the transparency of two or more planes overlaps, causes a pattern of visual interference. It is this optical disturbance that simulates the fluctuation effect.

Because Aida's original pencil drawings would be indecipherable if reproduced, he has prepared his illustrations in ink for this book.

DEMONSTRATION DRAWING

Mario Botta

Mario Botta studied art in Milan and architecture at the Istituto Universitario in Venice, from which he graduated in 1969. He then quickly emerged as one of the most outstanding young Swiss architects of the Ticino school. Botta has produced more than 40 buildings in 30 years and the sheer quantity and quality of his work, together with the diversity of his commissions, has made him one of today's leading Central European architects. A fair number of his constructed buildings can be found dotted about the Ticino region of Switzerland. Indeed, his collection of work there regularly attracts design students and professionals, paying homage on the 'Botta Tour'. Any such tour would have to include his famous series of private houses, most notably the Birdcage House in Riva San Vitale, the Radar House in Morbio Superiore and the much-analysed Casa Rotonda in Stabio, which is considered to be the most important example of his early work. Major works further afield include the San Francisco Museum of Modern Art (SFMOMA), Evry Cathedral in France and the Art Gallery in Tokyo.

Botta's formative period in the second half of the 1960s was profoundly influenced by direct working contact with two great masters of the Modern movement, Le Corbusier and Louis Kahn, and also by his teacher, Carlo Scarpa. Botta's buildings also take their cue from more historical architectural traditions in their use of primary forms such as the cube, the cylinder and the isosceles triangle. It is this reference to ancient forms, together with the influence of rural building techniques from his native Ticino, and the contemporary interpretation applied to it, that create his unique and recognizable design approach.

The result is an architecture that expresses solidity, permanence and, by linking the future with the past, continuity. His highly crafted structures exhibit clean geometric lines and a striated and variegated textural surface that exploits the potential of basic building components such as brickwork, blockwork and stonework.

These qualities are also clearly reflected in his prolific output of assured and high-definition drawings and sketches – a skill developed from having entered countless competitions. This sureness of graphic representation previews a range of sensations, however, that only the finished building will actually arouse, and focuses on the positive nature of its construction. In leaving no doubt as to his intentions, Botta's drawings are merely a means to an end, because the experience of a built architecture, Botta insists, '...is infinitely richer than the ideas, the designs, the projects of the architects themselves. The built thing is enriched by its relationship to reality.'

EVRY CATHEDRAL, France

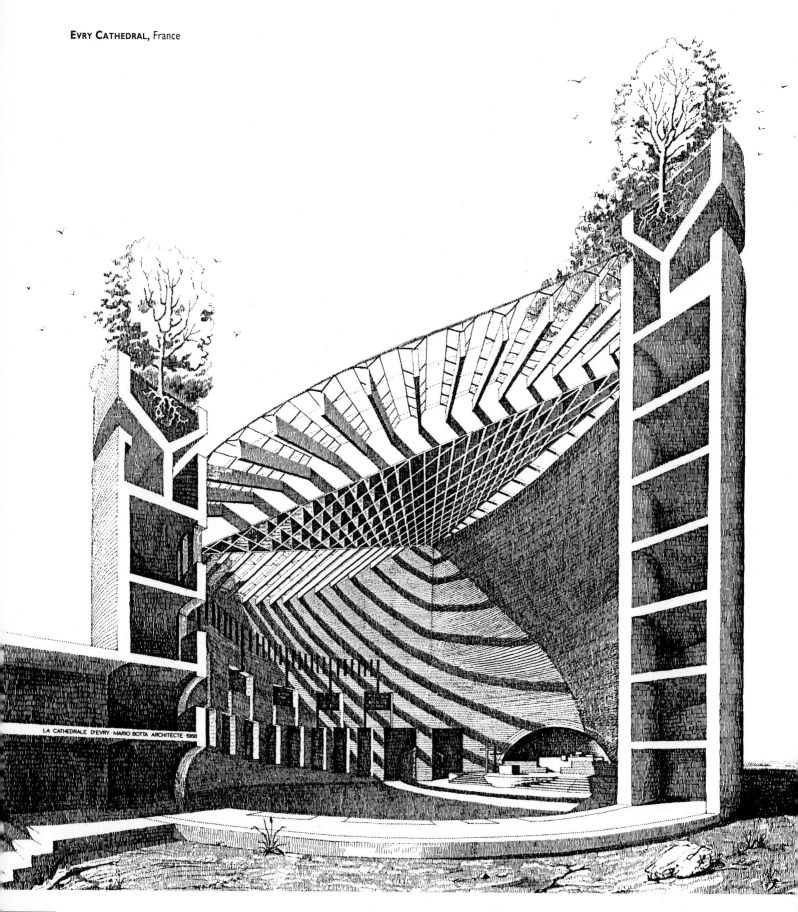

LA CATHEDRALE D'EVRY · MARIO BOTTA ARCHITECTE · 1988

EVRY CATHEDRAL, France, Sectioned Perspective

Ink on Tracing Paper, 82 × 82cm (33 × 33in)

This tonal rendering technique, composed almost entirely of dots and dashes, without any outlines, was worked directly over a guideline underlay. The layered structuring of the vertical dash system is used to depict masonry in shade and shadow, the layers being overlapped slightly to indicate coursework, or allowed to touch only when a smooth plane is described. Opening and closing the system of vertical lines gives a lighter or darker version of tone, its extent being disturbed or broken only when light is cast across its surface. Dots occur solely in the sunlit portions of the building, where the edges of mass and plane appear to erode under the intensity of light.

The result is an economical drawing of a building that appears to have existed from antiquity. It is an impression gained from a technique reminiscent of early engravings as well as from Botta's reference to the picturesque, a quality suggested by the depiction of circling crows, weeds, strewn rocks and baked earth.

THEATRE AND OFFICES, Varese, Italy,

Sectioned Perspective

Ink on Tracing Paper, 118 × 89cm (47 × 35½in),

(pages 38 and 39)

This competition drawing of a building designed in collaboration with Aurelio Galfetti employs a freehand textural tone, achieved by means of a 'basket-weave' clustering of parallel sets of short, but slightly curved, lines grouped in twos and threes. When applied evenly, this hatching technique produces half-tones that describe the surface effect of masonry when seen in shade.

The second tonal rendering technique used here is produced with the help of a straightedge. This is the broken-line hatching achieved by a regular raising and lowering of the pen, during ruling to cause a 'hit-and-miss' effect. This technique is used to good effect on the sunlit areas of the cylindrical building, to inscribe the pattern of coursework around its windows, and also in both vertical and horizontal directions to describe the pattern of masonry on the two frontal blocks .

EVRY CATHEDRAL

(Details below from main drawing opposite)

1 Botta's perspective is worked almost exclusively in a vertical ink-line hatch, with the density of its clustering being relaxed and tightened in response to reflected light and shade respectively.

2 For planes receiving direct sunlight, the hatch gives way to linear sequences of dots. These indicate both the scale of coursework and the inclination of the curving plane.

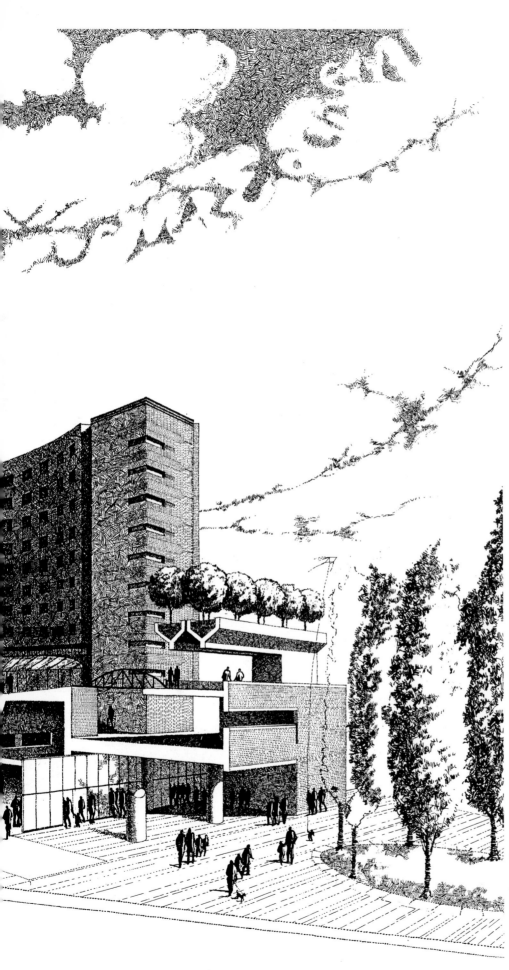

THEATRE AND OFFICES, Varese, Italy

1 Darker versions of tone are achieved by using (a) a thicker line weight; (b) a tightening up of the hatching; (c) a second layer of the technique superimposed on to the first.

2 This broken-line hatching is achieved by a regular raising and lowering of the pen during ruling to cause a 'hit-and-miss' effect.

3 The transition from light to dark on the near side of the cylindrical building brings together freehand and hard-line techniques to create an even tonal gradation.

Sir James Stirling

James Stirling graduated from Liverpool University's School of Architecture in 1950 and went on to form partnerships with James Gowan in 1963, and with Michael Wilford in 1971. The fruits of these associations are a series of internationally acclaimed buildings that established Stirling as the greatest British architect of the twentieth century. Stirling's first major project with Gowan, the notable Leicester University Engineering Building, exemplifies a tough machine aesthetic that, according to critic Kenneth Frampton, represented a breakthrough in contemporary British architecture. But Stirling's most famous and widely celebrated building – completed in 1984, designed with Wilford and representing a more romantic and neo-Classical phase in his work – is the influential Staatsgalerie in Stuttgart, considered by many to be his masterpiece. His association with Wilford also saw the realization of other masterworks, including the Sackler Museum at Harvard University, the Braun Factory complex in Melsungen, Germany and the popular Clore Wing of the Tate Gallery in London.

News of Stirling's sudden death in June 1992 sent shock waves through the international architectural community. This tragic event was not only to cause a widespread reaffirmation of his monumental contribution to contemporary architecture, but also focused attention on the legacy of his drawings. For Stirling, the architectural drawing was the vital language of building design. Indeed, every aspect of a building design had to be explored through an endless variety of drawings. 'A drawing', he once wrote, '...has to be designed (viewpoint critical). Elimination of information is the crux and is achieved through a series of design decisions, often taken quickly in sequence; sometimes taking a lot of deliberation (more likely to be the less succesful drawing). What is left on the image is the minimum required to convey the maximum information with the greatest clarity – related to how we "understand" the building as distinct from the way it might in reality look...'

This approach is reflected in his famous minimal, deadpan plan projections – axonometrics and isometrics that, in his earlier phase, tended to take a Modernist down-view, or bird's-eye stance. These drawings literally *become* the form, i.e., the edges of buildings, such as the Leicester Engineering Building and the later Cambridge History Faculty Building, which are both inextricably embodied in the angles and axes of their former orthographic representations. In 1968 Stirling also began to draw the up-view axonometric – a viewpoint partially disclosing wall and ceiling planes as seen from below. Occasionally used also by Mario Botta, this comparatively rare projection drawing was first promoted by August Choisy at the end of the nineteenth century to illustrate the spatial and structural organization of a building design. Its production involves flipping a plan drafted on transparent material for its upward extrusion into three dimensions. The resulting viewpoint allowed Stirling's mind's eye to penetrate the complex sequencing of unfolding volumes and spaces.

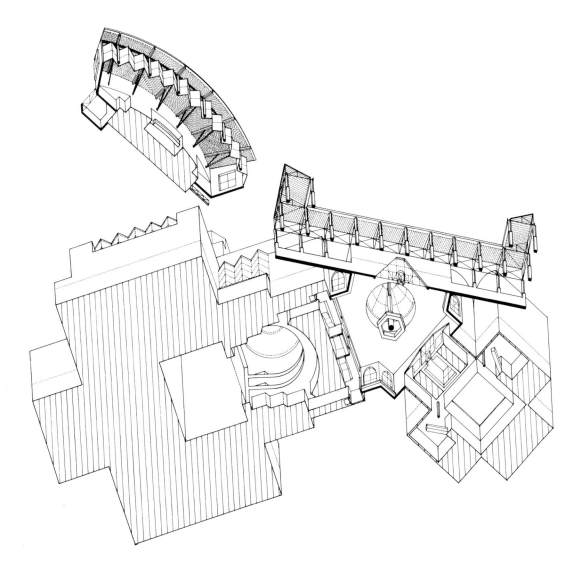

COMPTON VERNEY OPERA HOUSE

Always to the point, and displaying the utmost clarity and simplicity, these hard-line drawings respond directly to the complexity and sophistication of Stirling's design thinking. To paraphrase Walter Nägeli, these drawings show precisely what the building is about: no superfluous lines, just lucid transparency, no effects, just pure information. Stirling could complete in his mind what he saw on paper. The drawing provided a neutral basis on which to form an opinion, often leading to something new and unexpected.

COMPTON VERNEY OPERA HOUSE, Up-axonometric
Ink on Tracing Paper, 36 x 33cm (14^1/$_2$ x 13in)

Russell Bevington, who has been a member of Stirling's design team for many years, describes these drawings as the product of the many individuals who have worked with Stirling over a long period of time. 'They are executed with equipment ranging from Graphos pens, the early Rotring black pens, to Rotring's modern range. Sometimes drawn on tracing paper, detail paper or film, there is always a hierachy of lines, but there are no hard and fast rules; each drawing, to some extent, always displays an element of experimentation.'

Paul Rudolph

Paul Rudolph is one of the most brilliant and inventive architects of our time. His reputation in the United States was established long before the construction of any of his more important works, such as the Art and Architecture Building at Yale. The start of his remarkable career as an architect was in fact marked by the publication of his innovative pen and ink drawings during the 1950s.

Rudolph graduated from Harvard in the 1940s and was a contemporary of Philip Johnson and Eero Saarinen. During his student days he evolved a drawing technique that would best visualize his design ideas. Implementing a ruled version of the freehand cross-hatching found traditionally in artists' drawings, Rudolph's technique employed ordered sets of ink lines, arranged and superimposed in grids, to depict the effect of sharp sunlight playing on the surface of a building.

Much imitated by successive generations of architects, this rendering technique not only anticipated the advent of the modern technical pen in the 1950s, but was also highly suited to photomechanical reproduction and resizing. It still stands as the hallmark of Rudolph's amazing and enduring architectural achievements.

Rudolph's need to explore the inside of his buildings from exterior vantage points is also encountered in his elevation and perspective drawings, where glazing in the façade is often left unrendered in order to provide an unrestricted view from exterior to interior space.

Resolutely Modernist in his thinking and a great advocate of architectural drawing, Rudolph is specific about the function of drawings. He says 'I have reached a point where I hate "pretty drawings", because it is the idea that is important. I am interested in how people think, and that is what drawing is about. It is a means of assessing what comes directly from the brain to the hand.' Therefore, he dislikes the whole idea of the commercial interest shown in this type of drawing, as well as the idea of the architectural drawing show. 'It's much ado about nothing,' he says. 'For me, this preciousness is totally alien to the nature of what architectural drawing really is.' Rudolph insists that his drawings were never meant to be sold or exhibited in museums but suggests: 'It would be silly of me to say that I don't get a certain joy in making them but this is not the real intent. I get turned off when people take them too seriously.'

Rudolph's primary concern regarding architectural drawings focuses on the role each one should play in the study sequence of design. 'It would be wrong to assume that a single drawing could tell the whole story about a building. In my teaching days (Rudolph was Chairman of Architecture at Yale University), I refused to look at a student project unless I saw it presented in plan, section and elevation and, hopefully, one kind of three-dimensional drawing'. Furthermore, '. . . the quality of the drawing has nothing to do with the quality of the architecture. For instance, I have drawings that represent a breakthrough in terms of ideas, but which are just awful as drawings. It is all to do with whether or not one has the time and energy at that particular moment and, of course, the quality of the idea.'

Rudolph's study sequence of a developing design will often involve a large preparatory sketch which, in summarizing the overall scheme, distils the preceding paper trail of design. Worked in pencil on tracing paper, this sketch also enlists the basic hues of coloured pencils to clarify and code spatial and structural issues.

INSTITUTION HILL, Singapore, Bird's-Eye Perspective
Pencil and Coloured Pencil on Vellum,
122 x 73.5cm (48 x 29in)

INSTITUTION HILL, Singapore, Detail

These sketches are actually large diagrams that pave the way for a more determined version of the form. Worked objectively in colour, this latter type of drawing provides another step toward a resolved design.

Rudolph describes his ink drawings as being 'made to sell buildings'. He also describes the hatching technique as his means of 'depicting the unknown for a client in as clear a manner as possible'. He sees these drawings as idealized versions of the truth – the full psychological impact of a building being realized only after its construction. He also describes a close relationship between his hatching technique and the selection of building materials in the design process. For instance, he suggests that an absence of brickwork in his designs results, perhaps, from the fact that it is more cumbersome to draw. He is also troubled by the fact that he has not yet devised a satisfactory way of indicating reflective materials. In his buildings he often uses bush-hammered concrete, which, apart from its resistance to staining caused by weathering, can be drawn easily, using the linear rendering technique.

COLONNADE APARTMENTS, Singapore

Rudolph has created this complex and masterly drawing using a basic hatching technique that he has made his own. The drawing is almost entirely comprised of ruled lines, with the exception of the softened effect of the balcony and landscape planting, which are achieved by means of a controlled and light-sensitive clustering of dots.

The cross-hatching technique is used by Rudolph to depict three-dimensional architectural space, which means indicating direction and the multiple reflections of light. While hatching is a technique in which sets of lines are drawn in one direction only, cross-hatching occurs when multi-directional sets of lines are superimposed on one another, creating a 'wash' that acts as a screen through which light (the white of the paper) is filtered. Scales of light are increased or decreased by opening or closing the linear mesh; maximum shades of value are achieved by the overlay of horizontal and vertical sets of lines, together with left and right 45-degree diagonals.

A moiré illusion, that is, an optical shimmering mirage, can be created with cross-hatching when the superimposed sets of lines are at their most intense, or when the size of a hatched drawing is substantially reduced on a photocopier. The moiré effect will naturally occur in the darker regions of the rendering, and is an illusion which, depending on the density of the screen, can bring the suggestion of reflected light to the areas of deeper shadow – either as a soft, hazy glow or as a dazzle of speckled light.

COLONNADE APARTMENTS, Singapore, Perspective
Rapidograph Ink Line Drawing on Tracing Paper, 91.5 x 129.5cm (36 x 51 in)

A strong feature of Rudolph's one-point perspective drawing is the impression of depth which it gives in the horizontal plane. Even more striking though, is its impression of height in the vertical plane. Known as 'atmospheric haze' (aerial perspective), and more commonly implied in the horizontal plane in perspective drawing to simulate the greying effects of distance, this depth cue is used here to suggest the upward fading of the huge apartment tower. However, a closer inspection of the drawing reveals Rudolph's use of a progression of hatched and cross-hatched tonal scales as they move both upward and backward into the depth of the drawing.

The faces of the square and rectangular projections of the building that receive direct light are subject to an ascending tonal scale. At the lower end of the scale, the projections receive a tight vertical hatching, with occasional overlays of an incomplete 45-degree hatching to encourage a sense of overlap. As the scale progresses upwards, the vertical hatching relaxes and gradually opens, to simulate increasing greyness until, at the very top of the building, the hatching becomes fine and sparse.

A different tonal sequence is found in the shadows of the projecting balconies, which progress from a solid black near ground level, up through successive four-, three- and two-layer cross-hatching treatments, until the upper levels are reached, where a single-direction hatching made up of thinner lines is used.

COLONNADE APARTMENTS, Singapore, Details

1 One important aspect of Rudolph's technique is that while hatching on the face of the building remains vertical, he harnesses his cross-hatched sets of lines on receding planes to the perspective vanishing point. By reinforcing the spatial inclination of these planes, he increases the illusion of depth.

2 Another feature of the drawing is the use of a controlled vertical hatching to describe the curve of the columns. Here, a concentration of tightly-packed lines conveys the cylinder as it quickly curves into the shade on the left. By omitting some lines on the right side of the curve, a highlight is created.

Minoru Takeyama

Minoru Takeyama is one of Japan's foremost architects. He received two master's degrees: one from Waseda University in 1958, the other from Harvard Graduate School of Design in 1960. In 1965 he founded his practice, Minoru Takeyama & A/U in Tokyo, and achieved international recognition in the early 1970s with his two coloured towers, Ichi Ban Kahn and Ni Ban Kahn, built in Tokyo in 1970. These buildings became renowned for their 'supergraphic' walls – large external façades adorned with painted graphics. Throughout the 1970s and 1980s Takeyama received a steady stream of major commissions for office buildings, factories and hospitals, many of which attracted prestigious design awards. Apart from teaching visits to various overseas universities and several international exhibitions of his work, among them his representation in the '50 Outstanding Architects of the World' exhibit at the 1985 Belgrade Triennale, Takeyama's recent work includes the Kakameguro condominium and the International Port Terminal, both in Tokyo.

INTERNATIONAL PORT TERMINAL, Tokyo

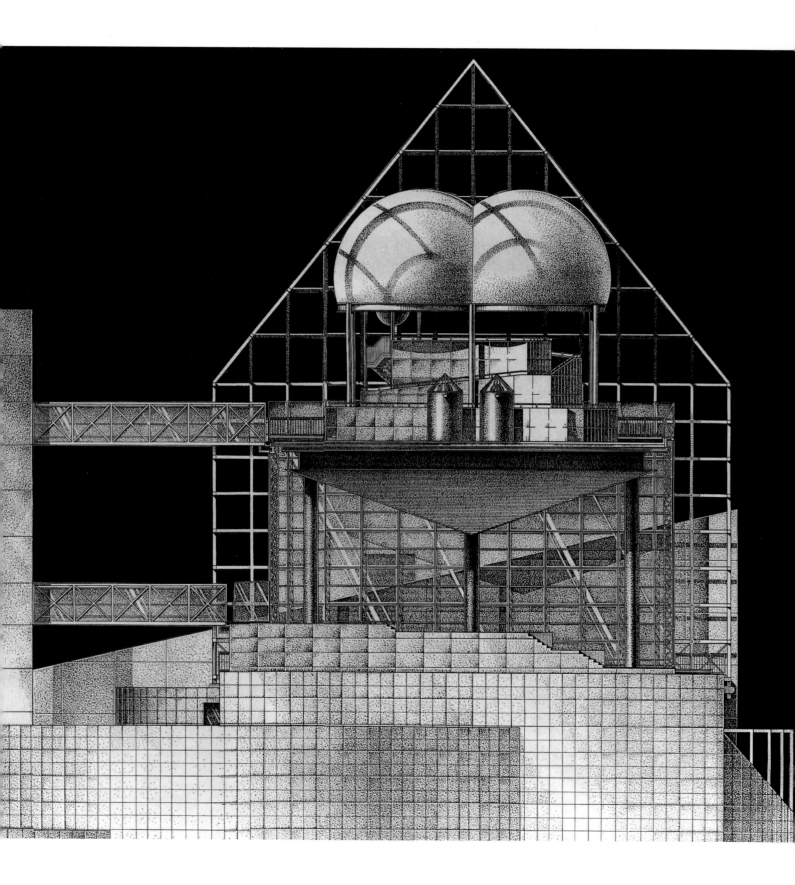

INTERNATIONAL PORT TERMINAL, Tokyo, Elevation, Scale 1:100
Ink on Tracing Paper, 84 x 59.4cm (33 x 23½in)
(pages 46 and 47)

Details (below) of Takeyama's dot-rendered drawing for the **INTERNATIONAL PORT TERMINAL BUILDING** in Tokyo:

1 Takeyama's rendering technique involves dots grouped and regrouped systematically, following the conventions of light, shade and shadow on basic geometric forms.

2 Takeyama's technique for glass uses a regular 'wash' of dots which gradually lightens from top to bottom; the wash is interrupted by angled rays of light grouped in ones, twos and threes.

3 The application of dots can be particularly descriptive of cylinders. These Takeyama divides into six vertical bands to suggest a progression from highlight to shade and reflected light.

While his countryman, Shin Takamatsu, favours the soft qualities of subtly shaded graphite to describe the metallic and highly-polished surfaces of his building designs, Minoru Takeyama employs the ink dot. The dot is the most basic graphic element; having no scale, it signals an energy point within a visual field. When clustered or scattered, however, a greater variety of energy and tension is released which, apart from creating patterns of tone and movement, implies depth and space in a drawing. For example, a microscopic inspection of a newspaper photograph will reveal that the image is comprised entirely of minutely printed dots, invisible in normal viewing conditions. Their number and varying proximity are interpreted by the eye to create recognizable pictures filled with form and space. This visual connection between clusters of dots and the illusion of depth stems from our everyday experience of atmospheric haze in the landscape, that is, objects in the far distance appearing as greyer and less determinate than nearer objects – a condition caused by the effect of sunlight on dust particles in the intervening atmosphere.

While portraying different surface conditions the dot system simultaneously confers an overall pointillist effect. More than other techniques, it is this effect that makes the drawing process simulate more precisely our visual perception of different planes.

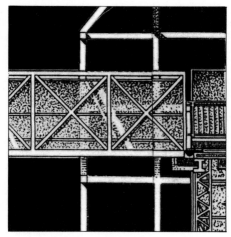
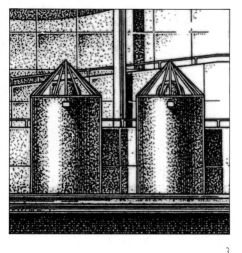

1 2 3

The history of the Richard Rogers Partnership goes back to 1963, when Richard Rogers established Team 4 with Su Rogers and Norman and Wendy Foster. In 1971, he set up in partnership with Renzo Piano, and in the same year they won the international competition for the design of the Centre

Richard Rogers Partnership

Pompidou in Paris. Since its opening in 1977, the Pompidou Centre has proved to be one of the most popular tourist attractions in Europe, drawing some seven million visitors a year (more than the Louvre and the Eiffel Tower combined). The Richard Rogers Partnership was formed in 1977, and a year later won a competition to design the new headquarters of Lloyd's of London. The much-celebrated building opened in 1986. Other major projects include the highly technical microprocessor laboratory for Inmos in Wales, the urban development plan for the City of Florence, and the restoration and total refurbishment of Billingsgate Fish Market in London. Rogers has received

Inspired by the aesthetics derived from modern industrial processes and rooted in a system involving fixed and flexible elements, the Partnership focuses mainly on public buildings. Designs are carefully evolved. The key elements of each building can be broken down into a collection of clearly identifiable parts that are programmed for growth and change. This strategy results in an architectural kit of changeable parts which, while retaining the integrity of its structure and silhouette, is capable of allowing the building to evolve in response to differing long-term and short-term needs. To achieve this end, radical planning solutions are employed, such as the removal of normal internal and vertical elements (stairs, lifts, mechanical services, etc.), from the inside to the outside of their buildings. This strategy clearly separates the 'served' and the 'servant' parts of a building. Consequently, well-lit and adaptable interior space is serviced by peripheral elements that can be readily maintained, upgraded or replaced.

Although the overriding theme in Rogers's work is one of architectural clarity and legibility, the underlying processes used to achieve this goal are often highly complex and sophisticated. This pattern is also discernible in the Partnership's drawings, in which the outstanding clarity of their depiction is the result of an intensive graphic preparation. Illustrated overleaf is one of a pair of section drawings by Rogers's partner Graham Stirk, which forms part of their widely published submission to the Tokyo International Forum Design Competition.

many honours and awards, including the Royal Gold Medal for Architecture from the Royal Institute of British Architects in 1985. In 1986 he was made *Chevalier de l'Ordre National de la Légion d'Honneur* in France and in Britain in 1991 he was knighted in the Queen's Birthday Honours list.

TOKYO FORUM, Japan, Details

(main picture opposite)

1 To animate the section drawing, figures, both in outline and in silhouette, are inserted, together with foliage and broken lines to denote the edges of beams of projected light.

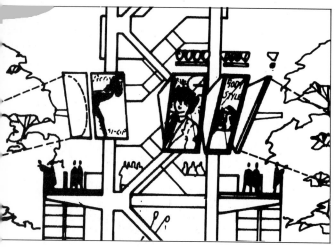

2 Screens are mounted on the vertical circulation towers and filled with projected images; in this case, resized images from Godzilla comics are photocopied on to Transtext film before being introduced into the drawing.

TOKYO FORUM, Lateral Section, Scale 1:200

Ink on Tracing Paper, 119 × 84cm (47$\frac{1}{2}$ × 33$\frac{1}{2}$ in)

The aim of the Tokyo Forum design was to distil a highly technical brief into a simple, coherent architectural solution. While creating drama and celebrating the ordinary, 'legibility' would remain as the key issue. The intention was that the scheme should be capable of being 'read' by laypeople, from the functional relationship of public space to its servant elements, such as structure and staircases, etc., through to the expression of its detail.

Influenced by the design process, which uses diagrams, scale models, sketches and analytical studies, the build-up to the section drawing was achieved by means of a sequence of overlaid illustrations. As only two section drawings were permitted by the competition brief, a trial series of sketched sectional cuts was made in order to determine the most descriptive one. Once isolated, a preliminary section was then sketched at 1:500 scale. This was designed to show many of the building's functions, including its service strategy. This section was later enlarged on a photocopier to the required 1:200 scale and formed the basis for a sequence of freehand overlay drawings, each one testing the viability of the scheme at an increasingly detailed level.

Pencil guidelines were then overlaid to test possible structural grids, establish levels and to set out the architectural elements more accurately. During this stage the drawing was worked in freehand using a fine fibre-tipped pen, a medium employed to 'systemize' the overall image. During this phase, however, elements such as the clusters of escalators, the configuration of the suspended halls and ground levels were studied, both in tandem and in isolation.

At this point the under-drawing existed as a montage of information, the result of an intensive, layered activity. In other words, being transformed and refined through the transparency of successive layers of tracing paper, the section had functioned as a design filter that now incorporated input from a variety of graphic and other sources, including that from structural engineers.

The most important layer of activity was represented by the final drawing. This was traced directly from the under-drawing on 120g tracing paper with a Rotring pen using three basic line weights. For instance, a 0.5mm point was used to pick out the line of the sectional cut; a 0.25mm indicated all the events behind the line of the cut; and a 0.18mm was used to delineate the delicate areas and objects appearing behind the plane of the glazing, the latter being depicted in a continuous, rather than a broken line.

A supplementary fourth stylus, 0.7mm, was used to insert the small shadows seen inside the shells of the suspended halls.

The details, including people, trees, cars, exhibits and banners, were drawn freehand by Stirk and inserted in 'hidden-line' fashion, that is, drawn before any part of the building that they obscured. Also, many of the images that appear on the monitor screens were taken from magazine advertisements and comic books – 'Godzilla' was a favourite source. These images were first reduced on a photocopier, copied on to Transtext transparent film, trimmed and then affixed directly to the drawing. Finally, to emphasize the sectional cut as it passes below ground level and beyond the building, a dark-toned dry transfer screen was applied.

The overall result is a skillfully drafted and visually effective drawing that emphasizes clearly the architectural intent of the project. Furthermore, by including a wealth of information, the drawing teems with life and allows the section to be viewed as a living mechanism.

TOKYO FORUM, Japan

This drawing (below) represents the end of an exhaustive design sequence involving countless overlays. Various overlays in the sequence incorporate input from different specialists in order to study the architectural form alongside its practical functions of structural viability and the inclusion of service systems, etc. In acting first as a design filter, the section in this ultimate stage is delineated as simply as possible to form a presentation drawing. This image, with the addition of some mechanical tones, uses three basic line weights to convey clearly its working parts. The insertion of figures, plants and vehicles give it a strong sense of activity and scale.

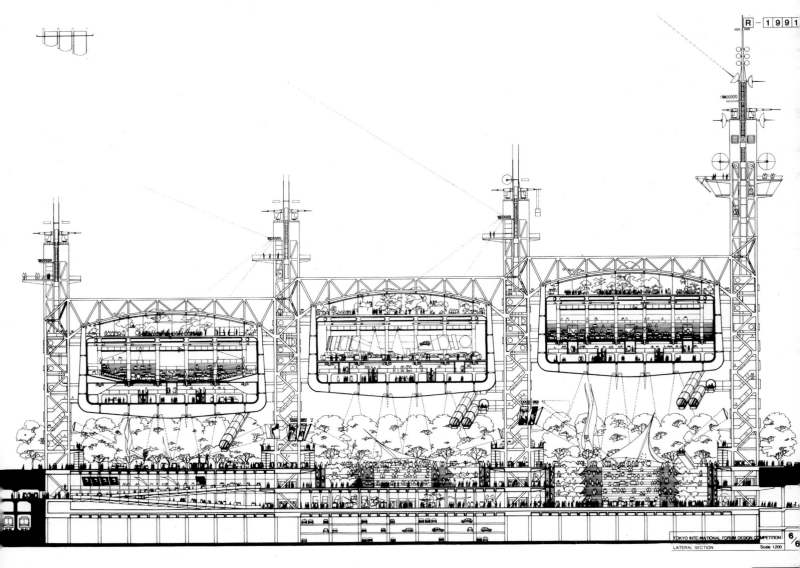

R - 1991

TOKYO INTERNATIONAL FORUM DESIGN COMPETITION 6/6
LATERAL SECTION Scale 1:200

Franco Purini

Franco Purini graduated from the Faculty of Architecture at the University of Rome in 1971, then worked in several architectural studios before moving to Milan in 1968 to begin a successful collaboration with Vittorio Gregotti. Their work included a series of prizewinning competition projects, including designs for the Universities of Florence and Calabria and for the Zen district of Palermo. Following a four-year period teaching architectural composition at the Istituto Universitario Statale di Architettura in Reggio Calabria, Purini returned to the Faculty of Architecture in Rome in 1982 to occupy the Chair of Design and Planning. Purini's international reputation is based on a prodigious output of writings and drawings, much of which has been produced in conjunction with Laura Thermes, his architectural partner since 1964.

LA CASA ROMANTICA, Elevation

Ink on Paper, 24 x 24cm (9¹/₂ x 9¹/₂in)

(Main picture opposite, details below)

Purini's drawings, made entirely using a Rotring Variant technical pen with a 0.3mm stylus, also function as graphic essays in tonal rendering techniques. Here (below), details taken from La Casa Romantica show how the extension of line into tone is not only a means of emphasizing architectural form and space, but also a means of structuring its rendered and unrendered areas to create a value framework which guides the eye around the format of a drawing.

Purini's remarkable graphics have been extensively published and exhibited, and his numerous publications include the book *L'Architettura Didattica* (1980) and an important folio of work, *Around the Shadow Line*, which was published in London in 1984 by the Architectural Association.

Purini is as celebrated for the outstanding originality of his drawings as for his finished buildings. While many architectural drawings seek to quantify and represent a projected building design, be it realistically or impressionistically, Purini's images are designed to question the very nature of accepted architectural thinking and to push back the frontiers of the architectural debate. Such drawings represent architecture in its purest form, often making direct reference to movements in art. They exist to put forward creative ideas, and are not working drawings of real buildings to be constructed.

The distinctive rapidographed images that are characteristic of Purini's work are often inspired by his deep interest in metaphorical and allegorical literature. Purini's drawings project theoretical landscapes, much in the tradi-

LA CASA ROMANTICA

tion of Piranesi, while reflecting his own ideal of a new architecture based on a coalescence of past, present and future.

His drawing technique has been described as 'archaeological' because of its flattened perspective, reminiscent of early Renaissance frescos where hill towns and cities were firmly placed in the background. In Purini's landscapes, however, the architecture is brought into the centre foreground and is often set against a backdrop of solid black – creating an isolating effect which echoes the gilded grounds in early religious paintings. The architectural form is then subjected to a painstaking and richly elaborate rendering process which emphasizes the impact of stark sunlight on each segment and creates a powerful sense of depth.

GLI ORDINI ARCHITETTONICHI, Elevation
Technical Pen and Coloured Markers, 70 × 100cm (27.5 × 39.5in)

This image (opposite) is a fine example of how Purini's drawing technique perfectly complements his method of colour rendering. Fine-tipped Stabilo colour markers are applied to convert a basic ink-line drawing into a controlled colour image, by using a range of cool blues, greens and yellows, accented with a warm brown-red. Close inspection of the colour rendering technique discloses a progression of three basic steps, from the precision of ruled sequences of coloured lines, to the freehand spontaneity of quickly applied strokes of colour. In its mixing of clusters of isolated strokes of different colours, the latter technique is reminiscent of the Pointillist painters, who applied a mixture of dabs of different hues to mesh together in the eye.

These details (below) show the range of rendering techniques used by Purini for **GLI ORDINI ARCHITETTONICHI** (opposite).

1 Sequences of ruled ink lines act as a guide for an overlay of single-colour marker lines which, when cross-hatched with lines of another colour, create a multicoloured mesh.

2 For a different effect, large areas of flat marker colour can be textured by the application of short flecks, either in a darker version of the same hue, or in a contrasting colour.

3 A third technique, similar to that used by the Pointillists, is achieved with short, freehand strokes of yellow, blue, green and terracotta, quickly juxtaposed to simulate natural foliage.

1 2 3

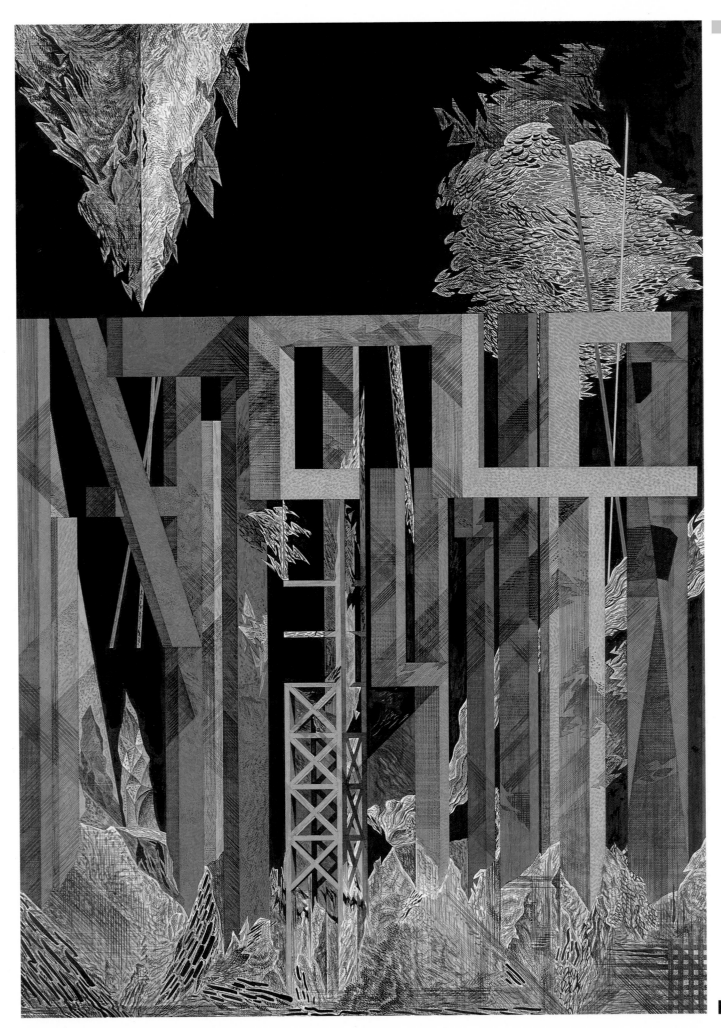

Henri Ciriani was born in Peru and studied architecture at Lima's National University of Engineering. He received his Diploma in 1960, together with a First Prize in Architecture and Art History.

Henri Ciriani

In 1964 he left for France and, after working in a number of private practices, set up his own office in Paris in 1976. Ciriani's subsequent international reputation is based on his highly regarded and award-winning social housing projects, which include those at Noisy-le-Grand, St-Denis, Evry, Lognes and Paris. Other realized buildings include his child-care centres in St-Denis and Torcy, the former receiving the Silver Triangle Award in 1983. He has also recently completed a competition-winning design for the First World War Historical Museum in Peronne. Ciriani's buildings have won several major accolades, among them the National Grand Prix of Architecture, 1983, and the Palme d'Or Nationale at Palmarès de l'Habitat, 1988, for his Evry 11 housing scheme.

Ciriani's designs have emerged from a doctrine that finds its roots in the early work of Le Corbusier, though they have progressed far beyond Modernism. His leaps of creative imagination result in a compelling architecture that explores a sculptural and sophisticated interplay of space, surface, light and colour. His highly thoughtful spatial modelling is previewed in beautifully economical colour drawings, where plans, sections, elevations and perspectives alike are clearly drafted against their intended settings, and bathed in a warm yellow sunlight.

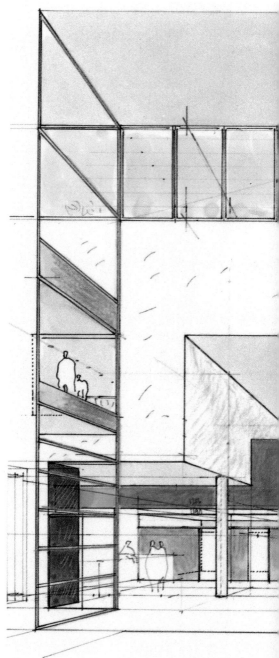

FIRST WORLD WAR HISTORICAL MUSEUM,

Peronne, France, Perspective Section (right)

Ink, Marker and Coloured Pencil on Tracing Paper, 42 x 29.7cm (17 x 12in)

Ciriani's one-point perspective section is constructed on an under-drawing, using an eye-level vanishing point located off-centre and coinciding with the lift. Using three line weights, 0.18mm, 0.25mm and 0.35mm, the ink line drawing is then developed on an overlaid sheet of tracing paper. Some evidence of additional construction, however, such as diminishing lines, centre

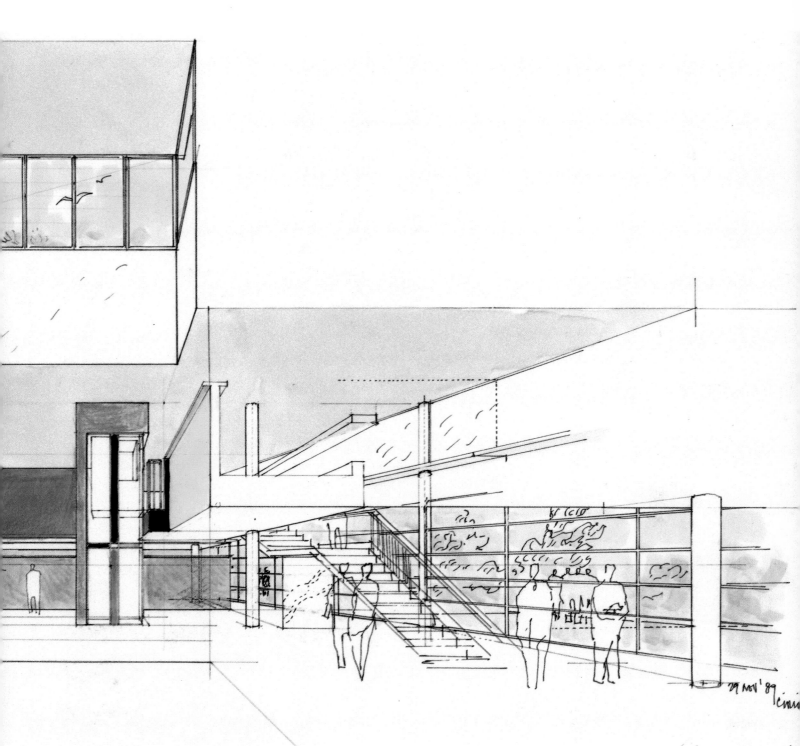

FIRST WORLD WAR HISTORICAL MUSEUM, Peronne, France

Colour, in the form of markers and coloured pencils, is a vital ingredient in Ciriani's drawings. Indeed, he insists that he is '. . . not a black-and-white drawing architect. Even if colour is not central to my work it is indispensable, always present in all stages of the working process.'

lines and measuring points, appears to take part in the finished drawing. Often removed carefully from such drawings, this manifestation of a preparatory construction tends to reduce the mechanical 'feel' of the perspective. Furthermore, it exists as an 'archaeological' clue as to its origins and imbues the finished drawing with the spontaneity of a quick sketch – a dynamic extended in this case by Ciriani's insertion of quickly sketched figures, foliage and birds. However, his use of line flecks to bring a sensation of surface to selected internal walls is reminiscent of Le Corbusier's drawing technique and, together with the deployment of occasional broken lines to indicate hidden points and planes, adds a sense of volume and transparency.

Ciriani's masterly economy of means is again reflected in his colour rendering which, generally speaking, applies marker to the back of the drawing and coloured pencil to the front. It begins with slabs of red, yellow, blue and black marker on walls against a transparent pale grey ceiling worked on the reverse of the tracing paper. When viewed from the front, this highlights a contrast between the various overhead interlocking and intersecting planes which, being arranged around the vanishing point, draw the eye to the central message area of the composition. This contrast is further heightened by his switch to a loose yellow pencil hatching over one of graphite applied to the face of the drawing to indicate the upper left-hand wall.

Elsewhere in the drawing can be found Ciriani's depiction of the play of light using two colours – often working one colour on the back, and another on the front, of the tracing paper. For example, a dark grey marker wash over a light grey registers the edges of upper floor levels, while a red-blue marker wash behind strokes of an umber-coloured pencil suggests the painted plane of the lower facing wall. Yet another two-layer colour rendering is also employed by Ciriani. This is his use of flecks of white pencil over a back-applied wash of dark grey marker on the reveal of the wall at the extreme left.

Finally, a third colour treatment describes the landscape setting, using a pale sky blue and two yellow-greens for foliage, each applied to the back of the sheet with a larger chisel-pointed marker.

FIRST WORLD WAR HISTORICAL MUSEUM,

Peronne, France, Longitudinal Section through Entrance, Scale 1:100

Ink, Marker and Coloured Pencil on Tracing Paper, 84.1 x 59.4cm (33$\frac{1}{2}$ x 23$\frac{3}{4}$in)

Ciriani's orthographic drawings exemplify a more controlled version of his two-sided marker and coloured pencil technique. Invariably set against a distinctive yellow marker background – in this case broken with hints of sky blue and a suggestion of foliage – his hard-line ink drawing receives a further marker rendering applied to the back of the sheet. This focuses on shadow

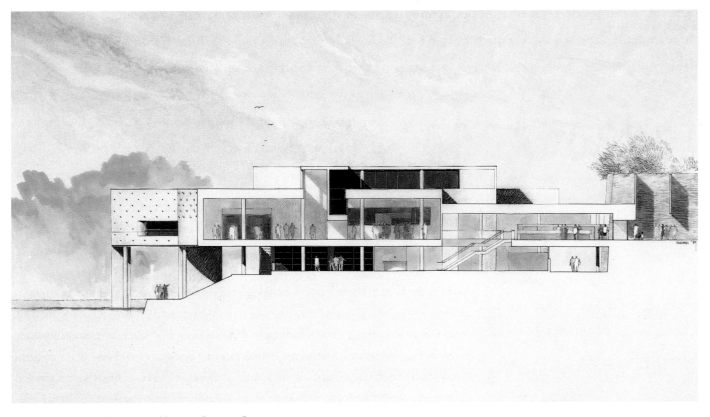

FIRST WORLD WAR HISTORICAL MUSEUM, Peronne, France

patterns, glazing and exposed end-wall elevations. Differentiation between interior and exterior views responds to the grey of shadows and glazing seen on the façade against the yellow glow of interior walls – in each case the marker washes are chromatically modified by a finishing touch of coloured pencil for shadows and walls, while the glazing receives a second marker wash on the face of the sheet.

Close inspection of Ciriani's two-layer rendering technique reveals its great potential in architectural drawing. Worked on the back of the tracing paper drawing, marker colours become slightly subdued when viewed from the front and they are further modified chromatically by the strokes of coloured pencils worked on the face of the drawing. When markers represent shadows on the building, Ciriani applies a systematic structure of hatched whited strokes. This not only modifies the tone of the grey but it also suggests the textural quality of the concrete, while simultaneously introducing the impression of reflected light. Meanwhile, on interior walls, the hues of coloured pencils are used to intensify the marker washes seen in the exposed galleries. This differentiation between exterior and interior space underlines an important aspect of Ciriani's approach to architectural design and provides a further example of the close working relationship between philosophical intent and graphic technique in this architect's work.

FIRST WORLD WAR HISTORICAL MUSEUM, Detail

The use of tracing paper as a filter for the harsh colours produced by markers is a technique common in architectural drawing. In Ciriani's case, marker washes applied to the back of the sheet can be modified with flecks of coloured pencil applied to the face of the sheet. However, these pencil flecks are a distinctive characteristic of his work and are as personal to him as his handwriting.

Tadao Ando

Tadao Ando's swift rise to international fame came in the early 1980s after the successful completion of his numerous and austere concrete private houses, including the box-like Azuma House and the Matsumoto House, built in his native Osaka. Unlike other top Japanese architects such as Kenzo Tange and Kisho Kurokawa, who were graduates of Tokyo University, Ando was disappointed with the instruction, dropped out of university and is almost completely self-taught. Despite this, his obsessive and highly individualistic design approach attracted commissions for an ever-increasing scale of building. These include his Rokko Housing and Chapel on Mount Rokko in Kobe, the Church of the Light in Osaka, and the Times 1.11 Building in Kyoto. His enormous success has led to his being in great demand as a teacher, especially in the United States, where he has taught at Columbia and Yale universities.

Church on the Water, Hokkaido, Japan, Plan, Scale 1:50
Pencil on Lithographic Print, 73 × 103cm (28³/₄ × 40¹/₂in) (opposite)

Ando's interest in the experience of sunlight and shadow, the sound of water and wind and reflection, is expressed in an architecture intended to appeal to all our senses. It is born of geometric order and fashioned with immaculate surfaces – qualities reflected in the impeccable blue rendering of this plan. However, its cool sophistication is in stark contrast to his more spontaneous and emotionally charged blue pencil sketch (right).

Behind Ando's architectural austerity is his deep interest in geometry, place and nature. He believes that the role of architecture is both to recognize and respond to its setting; that geometry is the means to realize this end and that, in so doing, nature will be given some kind of order. However, his architectural interpretation of nature is not one of an architecture with gardens or one covered with plants, rather it is one in which the elements of light, rain and wind can be directly sensed by a building's occupants.

These themes are the result of his first visit to Rome when, looking up into the dome of the Pantheon, with its skylight open to the elements, he realized that its underlying vertical geometry (also experienced by him in the upward thrust of the imaginary architecture seen in Piranesi's engravings), contrasted sharply with his own culture. For instance, traditional Japanese buildings express horizontal space and, being without a formal geometry, blend into the natural landscape. Consequently, the merging of Japanese and Western architectural traditions is a major preoccupation in his work.

Church on the Water, Hokkaido, Japan, Sketch
Blue Pencil on Yellow Tracing Paper, 32 × 27cm (12³/₄ × 10¹/₂in)

After studying at the Technische Hochschule in Munich and the Illinois Institute of Technology, Helmut Jahn became partner, and in 1982, president, of his company Murphy/Jahn. The firm, based in Chicago, has realized 60 works, most of which are in the United States. More recently, his international work has also been receiving attention, with the completion of the Messeturm building in Frankfurt, Germany, Europe's tallest office building. His other public buildings include, to name but three, the Park Avenue Tower in New York, the State of Illinois Center in Chicago and the United Airlines Terminal at Chicago's O'Hare Airport. According to John Zukowsky, Curator of Architecture at the Art Institute of Chicago, Jahn's buildings have exerted a 'staggering' influence on world architecture. Furthermore, Jahn is described by the American Institute of Architects as 'one of the ten most influential living American architects'. His work has won major awards and has been the subject of countless international exhibitions.

Helmut Jahn

STATE OF ILLINOIS CENTER, Atrium

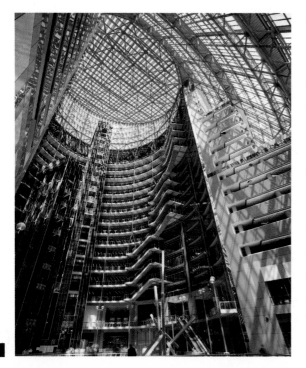

Although Jahn's work is not exclusively devoted to monumental buildings, it is the sheer size and number of his high-rise commercial structures that, by their dominating presence in major cities and repeated exposure in the media, have entered the public consciousness. Despite their huge proportions, however, these buildings express a sense of human scale – a scale that emanates from the delicate handling of space, form, lighting, colour and materials. Each Murphy/Jahn building also displays its own character; an identity derived from a design process that is both rational and intuitive.

This design approach is best detected in Jahn's vigorous but delicate ink line drawings. In fact there exists a remarkable similarity between the qualities found in these graphics and the actual experience of his architecture (left). Jahn's distinctive and fragmented drawing sequences provide a cartoon-like storyboard of multi-view images through which he explores and shares his evolving design ideas (see pages 64-66). These 'frames of reference' take us on a visual journey in and about the space of his design: at one moment we are suspended in the space above a plan, at another we zoom in for a close scrutiny of detail. Next we are offered head-on views of alternative elevations seen from the four compass points, before being taken into key interior spaces.

Each view is bathed in an atmospheric haze of light, an impression generated from Jahn's undulating yet rhythmic line-drawing technique. If we move in even closer, we find that his technique results from the skilled control of a fast-moving, flickering ink line. Worked in conjunction with the architectural delineation, this rust-coloured wavy-line 'mesh' can darken when superimposed, or instead be made to pulsate when touches of colour from a coloured pencil are added to it. A much-copied technique, it has become the familiar trademark of Jahn's distinctive graphics.

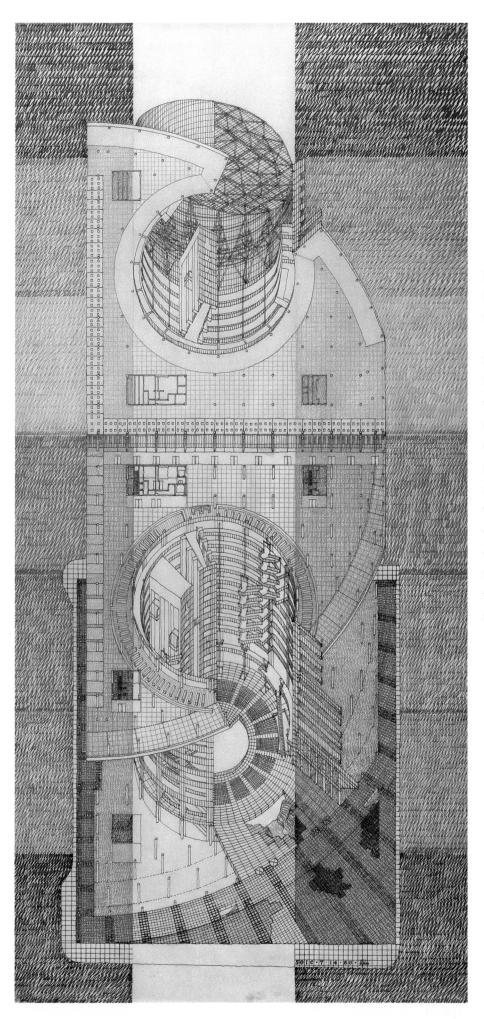

STATE OF ILLINOIS CENTER, Chicago, Up and
Down Axonometric

Coloured Ink on Paper, 99 x 178cm (39 x 70in)

Some of Jahn's earlier drawings are made up of
individual blocks of different coloured ink lines
which, in previewing the actual colour of the building,
call upon a close harmony of hues, ranging from
earth browns and yellows to greyish blues. More
recently, however, his drawings have conveyed a
richer chromatic range; earth colours turning to
vibrant scarlet, green and red-blue. Additionally,
coloured pencils, which were formerly employed
only as an adjunct to his ink line, now work in
unison. In bringing sharp, clear hues to the drawings,
the new ink and pencil colours combine to achieve a
scintillating effect.

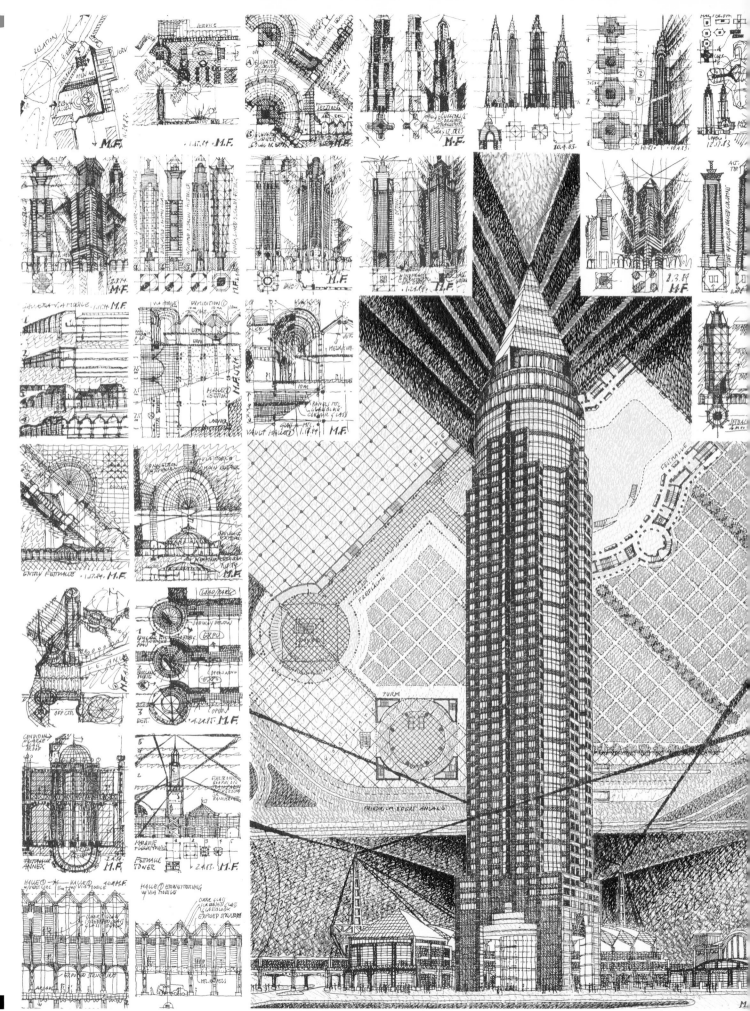

MESSETURM AND MESSEHALLE BUILDING, Frankfurt

Lithograph from Sepia Ink on Paper Drawing, 96.5 x 68.5cm (38 x 27in)

Jahn's superb drawings are powerful examples of the link between style of drawing and style of architecture. But if architectural graphics mirror architectural intention, then the shift in technique in Jahn's later drawings reflects a corresponding gear change in his design approach. Be that as it may, Jahn is insistent that, rather than ends in themselves, his drawings express the complexity, conceptions and aesthetic ideals of his buildings. After all, he says, the drawings are made with the exclusive and overriding concern that, ultimately, '. . . it is the building that matters at the end'.

MESSETURM BUILDING, Details

1 A rust-coloured line, drawn with a technical pen, is added, then undulating lines applied in such a way that they can breathe, to suggest different effects and different scales.

2 Superimposed sets of undulating lines are applied in different colours to produce scintillating colour progressions.

3 These two-coloured progressions can be controlled by size of undulation, to create more formal surface textures that tighten for darker tones and open for lighter tones.

1

2

MESSETURM AND MESSEHALLE BUILDING,

Frankfurt

3

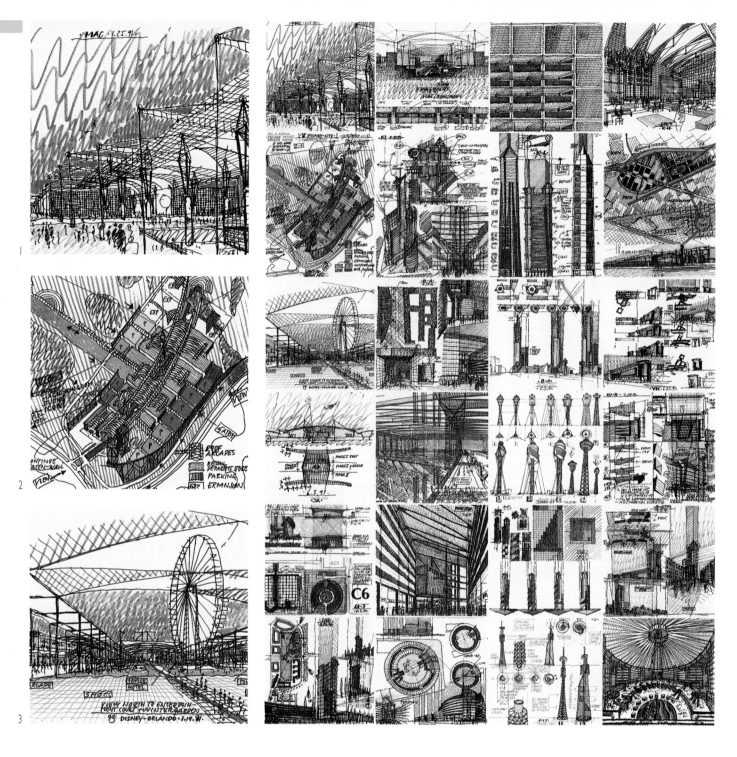

PROJECTS 91 Lithograph of Coloured Ink and Coloured Pencil on Paper, 68.5 x 96.5cm (27 x 38in)

Jahn's more recent drawings frequently include the use of his Mont Blanc and Porsche pens. The Projects 91 lithograph is notable for the following techniques:

1 Jahn's newer drawings use a black outline which encloses vibrant combinations of primary colours in inks and coloured pencils.

2 Jahn's colour use now operates in two ways. First, drawings can be made exclusively in line, using several colours to colour-code planning zones or architectural elements.

3 A second technique is the use of coloured pencils using various hatches to (a) define form, (b) describe surface modules and (c) invoke an illusion of space in the drawing.

Stanley Tigerman received his architectural degrees from Yale University in 1960 and 1961. After working for a period in the offices of George Fred Keck, then Skidmore, Owings & Merrill, and Paul Rudolph, he set up in private practice in 1962. Later on, in 1988, he founded the Chicago-based

Stanley Tigerman

Tigerman McCurry partnership with his wife. The practice has since produced almost 200 architectural projects, including buildings throughout the United States as well as in Japan, Germany and Bangladesh. The most notable early examples from a remarkable body of work include the famous Hot Dog House in Harvard, Illinois, the Daisy House in Porter, Indiana, and the Illinois Regional Library for the Blind and the Physically Handicapped in Chicago – buildings that were to reach a wide international audience. Tigerman is also a leading educator and was Director of the School of Architecture at the University of Illinois from 1985 to 1993. He is the recipient of numerous national honours and awards and his work has been exhibited at the Museum of Modern Art, New York, the Venice Biennale and the Museo di Castelvecchio in Verona.

While a student at Yale, Tigerman was never fully convinced by the pervading Miesian Modernist design culture of the time. Indeed, his interest in the idiosyncratic and the diverse motivated an exploration of architectural displacement and disjunction; issues constantly addressed in his subsequent slashing and splitting of pure form. This theme is clearly demonstrated by several of his buildings which, being centrally sectioned, are, like a stone containing a fossil, pulled apart to reveal a glimpse of their inner secrets. Occasionally, one half of the resulting separation is transformed – a condition perhaps best exemplified in his unrealized Little House in the Clouds project in which Tigerman combines architecture and topiary in equal measure. This fascination for the cleaving and counterpointing of form sees his personal geometry exploring both subtle and adventurous variations of a rectangle rotated within a square, a cube tilted and sliced by a spatial gash, 'snapped' rectangles and superimposed grids. It is a continuing attempt by Tigerman to effect a state of closure by healing the architectural 'wound' (but never quite accomplishing it) that drives his work forward.

BATHING PAVILION, Axonometric

Coloured Pencil on Watercolour Paper, 61 x 61cm (24 x 24in)

Tigerman's drawings probe the solids and voids of his designs and convey data in the form of multiple images. Tigerman himself sees his drawings as functioning in two ways. Firstly, they complete the circuit between idea and hand, while simultaneously projecting and transmitting information. Secondly, the same drawings provide a line of communication with his clients, whose active participation in the process of design is encouraged by him. Consequently, the drawings and renderings that emanate from his office are immediately accessible and inviting to all viewers.

CAREER COLLAGES, Perspective
Ink Line Drawing with Coloured Pencils and Fibre- and Felt-tipped Pens, 113 x 78.5cm (44$\frac{1}{2}$ x 31in)

Tigerman's graphics also include his playfully animated ink line drawings which he calls 'architoons'. These drawings represent a game using a repertory of forms with historic connotations that are also present in many of his buildings. The often complex and humorous arrangement of figures and objects in his archi-toons are picked out using solid and transparent colour hatches applied in vertical, horizontal and diagonal lines. When more amorphous shapes are rendered, such as clouds, these are simply colour-tinged at their edge. The emphasis of an almost heraldic figure ground pattern stems from Tigerman's singular use of a vertically hatched line reserved for the background planes — its harmonic colour shifts resulting from coloured pencil mixtures that materialize during application.

Tigerman's Pop Art theme of disjunction, and of the juxtaposition of opposites to form a new whole, is well demonstrated in his architoons. Functioning

as humorous and, at the same time, sarcastic commentaries on the American way of life, they appear as a tapestry of fragmented images populated with angels and devils and teeming with references to fun and seriousness, good and bad. This constant dichotomy in his work has attracted comparisons with the drawings of Claus Oldenburg, Saul Steinberg and John Lennon. In reflecting Tigerman's architectural reminiscences as they relate to the actual realization of architecture, however, they have helped to restore the influence of the architectural drawing. Indeed, his architectural drawings have been elevated to the status of an art form.

CAREER COLLAGES, Perspective

Lebbeus Woods

Lebbeus Woods is an architect and critic who graduated from the University of Illinois School of Architecture in Champaign-Urbana in 1964. He has been Visiting Professor of Design at Harvard University, Columbia University, The Cooper Union School of Architecture, and the Southern California Institute of Architecture (SCI-ARC), and is co-founder of the Research Institute for Experimental Architecture (RIEA). Labelled a 'futurist' and a 'visionary', he insists that his work has nothing to do with these terms, but is intended – like the work of any architect – for realization in the present. He has lectured and exhibited his works internationally and his recent monographs include *Anarchitecture: Architecture is a Political Act*, published in 1992 by Academy Editions, London, and *The New City*, published in 1992 by Simon & Schuster, New York. Woods lives and works in New York City.

ZAGREB-FREE-ZONE, Perspective
Coloured Pencil on Strathmore Bristol Board,
20 x 30.5cm (8 x 12in) (page 72 and opposite)

The regularity of the Strathmore board grain gives this image the impression of tiny dots of pigment, similar to the minute pixels of colour that make up a computer image. The resulting atmospheric haze is similar, albeit achieved by different means, to that present in Tschumi's graphics (pages 147-50).

Woods describes the drawing process as the means of making architecture tangible. 'Drawing', he suggests ' . . . is the codification of architecture; architecture is the codification of knowledge, and my drawings address issues as to what this knowledge is'. Therefore, Woods's theoretical approach to the design of architecture is quite the opposite of a conventional approach, i.e., the fashioning of space and form to accommodate predetermined emotional and physical responses. Rather, Woods proposes the creation of architectural events that cannot be understood in advance, nor their effects predicted. In other words, his enigmatic constructions have to be confronted on their own terms, a confrontation through which we are invited to discover and interpret their potential for use and habitation. Indeed, it is this act of discovery, he believes, that attunes our perceptions to a higher degree of consciousness and receptivity.

To study one of Woods's complex drawings is to journey into a strange and unfamiliar landscape, populated by an as yet unknown civilization. But our experience is also one of an essentially natural and human architecture that, although shrouded in mystery, celebrates the play of light on form, often revealing materials and surfaces marked by time and weathering. As postcards from a world parallel to a more familiar one, his drawings simultaneously speak about the past and the future, yet are at the same time entirely contemporary.

Our journey into the Woodsian landscape, however, is also tempered by the familiar coordinates of orthographic and perspective projection, and their attendant frames of reference. Resulting from a tenaciously clear and objective vision, and using drawing styles familiar from the nineteenth century, Woods's drawings bring to mind the techniques of the Surrealists. The idea of employing a familiar medium to record an unfamiliar experience was also used by Salvador Dali, whose systematic oil painting technique, in which traces of brushstrokes were carefully removed, was used to create an almost

photorealistic impression of dreamlike landscapes. The realism of Wood's drawings, however, is a realism rooted in the organized clusters of hatched and cross-hatched ink and pencil lines.

But Woods insists that his drawings should not be viewed as an art form, but seen in relation to society and the human condition. From his essentially philosophical standpoint, his interest in drawing functions as a means of developing ideas about architecture in relation to social issues.

ZAGREB-FREE-ZONE, Perspective
Coloured Pencil on Strathmore Bristol Board, 20 x 30.5cm (8 x 12in)
(page 71)

While Woods's ink line drawings focus on contour and shape, his coloured pencil drawings focus on the subtle differentiation provided by colour. Being an intrinsic property of light, colour is used by him to explore its presence in the fantastic regions described by his drawings. To do so, background areas of the image are rendered evenly, with colour mixes and colour changes resulting from gentle strokes of the pencil that respect the textured surface of the paper. This causes the regularity of the Bristol board grain to express tiny dots of pigment – an effect similar to the minute pixels of colour that make up a digitized image. This grainy effect is also maintained in middleground and foreground areas where the colour-diffusing effect of the paper's 'tooth' (texture) can be seen within individual pencil strokes as they describe the more clearly focused surface texture of nearby materials. This achievement of a pervading atmospheric haze is similar, albeit accomplished using quite different means, to that present in Bernard Tschumi's graphics (see pages 147-50). It is a powerful depth cue that, in making direct reference to the way we perceive near and distant forms in the landscape, imbues Woods's drawings with a sense of a fantastic architecture and gives it a dramatic presence.

BERLIN-FREE-ZONE: FREESPACE INTERIOR
Coloured Pencil on Strathmore Bristol Board, 20 x 28cm (8 x 11in)

This superb drawing again exemplifies Woods's skills in utilizing the grain of the paper support to create an illusion of graphic depth. However, the extreme dynamic of this interior space stems from Woods's disciplined use of single-directional and cross-hatched lines that reinforce the energy of its tonal structure. Meanwhile, his employment of a subtle, almost neutral, colour range further emphasizes the turbulent composition; the trajectory of coloured, linear elements, while contrasting with the stillness of the white cube, draws the eye into the upper-right quadrant.

BERLIN-FREE-ZONE: Freespace Interior (opposite)

Michael Graves

Michael Graves practises architecture in Princeton, New Jersey and is Professor of Architecture at Princeton University, where he has taught since 1962. He was educated at the University of Cincinnati and at Harvard and received the Rome Prize for Architecture from the American Academy in Rome for 1960-62. He was also the recipient of two national honour awards from the AIA (American Institute of Architects) and the Arnold W. Brunner Memorial Prize in Architecture in 1980. Graves quickly became established as an influential architect who, perhaps more than any other of his generation, entered the consciousness of the general public through his widely published drawings, even before his buildings were constructed. The drawings herald his elaborate and colourful designs for the neo-Deco buildings that have so impressively entered the landscape and skylines of many American cities. His distinguished list of completed works includes the Portland Building in Oregon, the Humana Building in Louisville, Kentucky, and the Swan and Dolphin Hotel for Disneyland in Orlando, Florida.

The interest in Graves's coloured pencil drawings led to him being 'discovered' by the New York art market over a decade ago when, in 1979, the Max Protech gallery exhibited a number of his drawings executed on flimsy yellow tracing paper. These drawings were quite different from any other architectural graphics. Hitherto, environmental design drawings appeared indecipherable to the untrained eye, demanded a close scrutiny to make any sense of them, and often appeared drab and dull. Conversely, Graves's colourful drawings, on a more human scale, provided a three-dimensional architectural preview that struck a chord with a public ever more inquisitive about architecture. Having raised the status of the architectural drawing, Graves led the vanguard of a small group of architects, mainly American, who had entered the public domain and reached a non-specialist audience. Consequently, beyond his major contribution to the architectural debate, Graves also began to influence other areas of design, such as interiors and furniture. Furthermore, the upsurge of commercial interest in pastel colours in the mid-1980s in Europe and Japan, has been traced to the distinctive Mediterranean hues found both in Graves's drawings and on his finished buildings.

A closer examination of the role of drawing in Graves's design process reveals three main categories of drawing, each addressing quite different avenues of communication. Design begins with the generative sketch, through which initial concepts are tested and transmitted. By their nature, these are deliberately experimental and consist of delicate ink line drawings worked in a sketchbook. These are followed by his famous preparatory serial studies, worked in coloured pencil on tracing paper, which refine and consolidate the idea conceived in the preliminary sketch. Finally, in the third category, is the definitive drawing which attempts accurately to represent the resolved design to others.

IZUMISANO BUILDING, Izumisano, Japan, Elevation
Coloured Pencil on Yellow Tracing Paper, 18 x 16.5cm (3¼ x 6½in)
Main picture (below), Detail (right)

Worked completely in freehand on yellow tracing paper, Graves's preparatory study is rendered quickly in his familiar, muted range of Mediterranean hues. His coloured pencil technique could not be more simple; sketched loosely over a guideline underlay, a black Prismacolour line drawing receives a rapidly applied rendering comprising two red-browns and two blues. The highly receptive nature of the tracing paper allows Graves to achieve subtle colour shifts caused by his juxtaposition of the warm and cool components of his restricted palette. The entire rendering conforms to a diagonal stroke discipline which, because he is left-handed, shows the sunlight entering the elevation from the upper right, rather than the more conventional upper left.

Virtually unknown in Europe until recently, yellow tracing paper is the stock-in-trade of American architects such as Graves. Known disparagingly as 'bumwad', it is used by him across the design process, from origination to presentation. More recently, bumwad has appeared in some British design offices.

Graves's seemingly tentative rendering style results from a lightness of touch and a speed of application. But this apparent timidity disguises his utter control of the medium. His subtle combinations of hue such as the deep blues mixed with terracotta browns on the façade, and the sky blue of the glazing, each allow the warmth of the yellow tracing paper to glow. This technique of involving the ground colour is much used by artists and is particularly evident in the paintings of Edouard Vuillard and Pierre Bonnard, who created colour mixtures that evolved in the eye of the viewer.

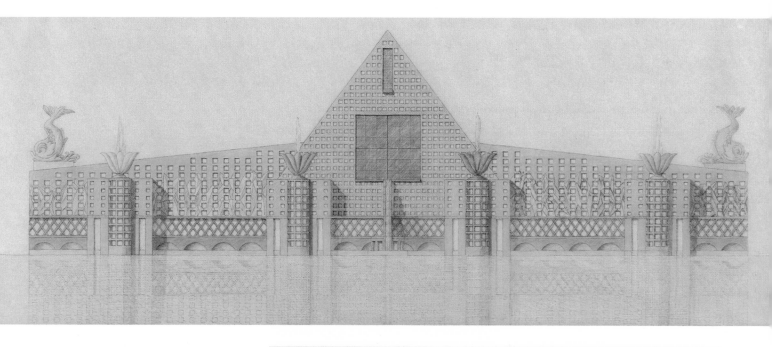

SWAN AND DOLPHIN HOTEL, Disneyland, Florida,

Elevation

Coloured Pencil on Yellow Tracing Paper,

55.6 x 164cm (22^1/$_4$ x 65^3/$_4$in)

(Main picture above, detail right)

This large drawing represents the tightening of
Graves's 45-degree rendering style into a more
painstaking and definitive drawing of his design for a
hotel built in Orlando, Florida. The familiar
Gravesian colour range employs a warm scheme,
comprising terracotta and orange against the pale
yellow of the drawing surface – a complementary
grey-blue being enlisted to contrast the central
architectural form, glazing, and features such as the
mural and the dolphin sculptures. Both this drawing
and the sketch for the Izumisano building display
similar rendering techniques which combine a
simultaneous sense of control and spontaneity; the
main differences between the two being size of
format, speed of application and, of course, the
difference between a drawing of a design idea in flux
and one that is fully resolved.

Arquitectonica was founded in Miami in 1977. Two of its founders, Bernardo Fort-Brescia and Laurinda Spear, have remained as principals since its inception. Fort-Brescia received his master's degree from Harvard University, while Spear studied fine art before gaining her master's degree in Architecture from Columbia University, New York. Described by the celebrated American architect Philip Johnson as the 'gutsiest team in the business', Fort-Brescia and Spear epitomize the new generation of Modernist architects in the United States. One of their first buildings, the Atlantis in Miami – the building with a hole punched at its centre to make way for a red spiral staircase and a tilted palm tree – became the trademark of the television series *Miami Vice*. Furthermore, it came to symbolize Miami's rebirth as an important metropolis. Many successful buildings followed; each using simple forms in a sophisticated manner, and each pursuing their themes of contradiction, surprise and inexplicability. They include the huge Sawgrass Mills shopping mall in Florida, the Bank of America building in Beverly Hills, California and the Miracle Center in Miami.

Arquitectonica

Arquitectonica's buildings begin life as two-dimensional drawings before being transformed into visually powerful perspectives and axonometrics that preview their future existence in three dimensions, either as scale models or as actual structures. It is their axonometrics that provide a viewpoint from which their attention-seeking language of slicing, colliding and penetrating forms are best explored, however. This interplay of form and surface, together with a paradoxical use of building materials, is akin to the art of collage. Indeed, Fort-Brescia cites as an inspiration the patterns and colour mixes found in the collages of Braque, Picasso and Léger. Also, being an artist as well as an architect, Spear is interested in a painterly approach that involves exploring the possibilities of representing pictorially the juxtaposition of flat surfaces and sculptural volumes. Colour is always a crucial element and is integrated in a compositional manner to communicate ideas about façade or geometry and to distinguish between various building materials and forms. Most of Arquitectonica's drawings are produced by Spear, who explores colour in the media of coloured pencils and, more especially, pastel. Indeed, she describes the whole image of a building design as emanating from a colour sketch. 'The sketch may take only a few minutes to do. But, if it is a compelling image that strikes us as the right direction for a project, thereafter we spend weeks and months developing the project [and] trying to get back to the look and feeling of that first moment of inspiration. Sometimes the image that we draw is not even architectural *per se* but just a mood or an ambience or even a palette of colours and textures.'

BANQUE DE LUXEMBOURG, Axonometric

Pastel on Strathmore Museum Board,

73.5 x 102cm (25 x 40in)

This image (right) displays an unusual use of the pastel medium since its inherently dusty quality has been harnessed in a hard-edged orthographic. However, the subtle colours associated with this medium are fully exploited.

VIEW FROM THE BABYLON AT NIGHT, Perspective

Graphite and Coloured Pencil on Paper,

14.5 x 27.5cm (5³/₄ x 10³/₄in) (opposite)

Arquitectonica's presentation drawings are usually the result of a team effort, but this one-point perspective was produced entirely by Laurinda Spear. It depicts an upper balcony of their Babylon condominium situated in Biscayne Bay, Miami, but its strong sense of colour and theatre betrays her earlier background as a fine art student.

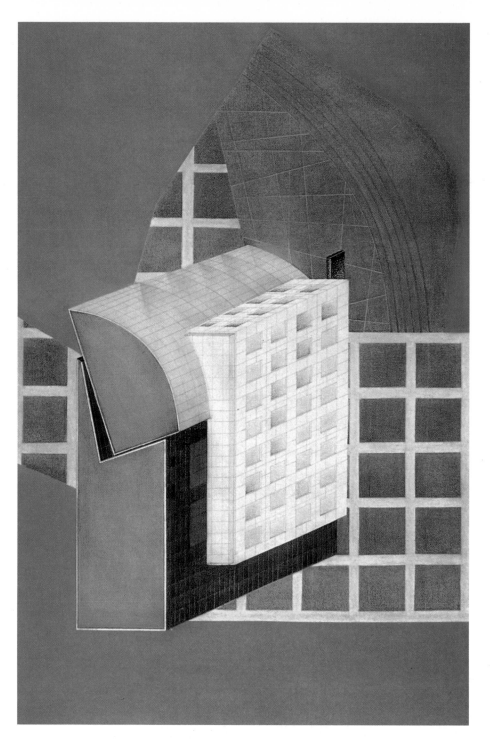

BANQUE DE LUXEMBOURG, Axonometric

Pastel on Strathmore Museum Board, 73.5 x 102.5cm (25 x 40in)

While some of Spear's drawings begin as computer delineations, the initial outline of this axonometric was transferred on to Strathmore Museum Board using a photocopier. Then, layers of pastel are introduced and built up directly using hues from a mixture of different pastel types. To control the spreading nature of the medium, especially as it is deposited on the 'tooth' (texture) of the paper, crisp edges are achieved using a combination of tools and materials including a straightedge, tape and an eraser mask. The final rendering is sprayed with several layers of fixative.

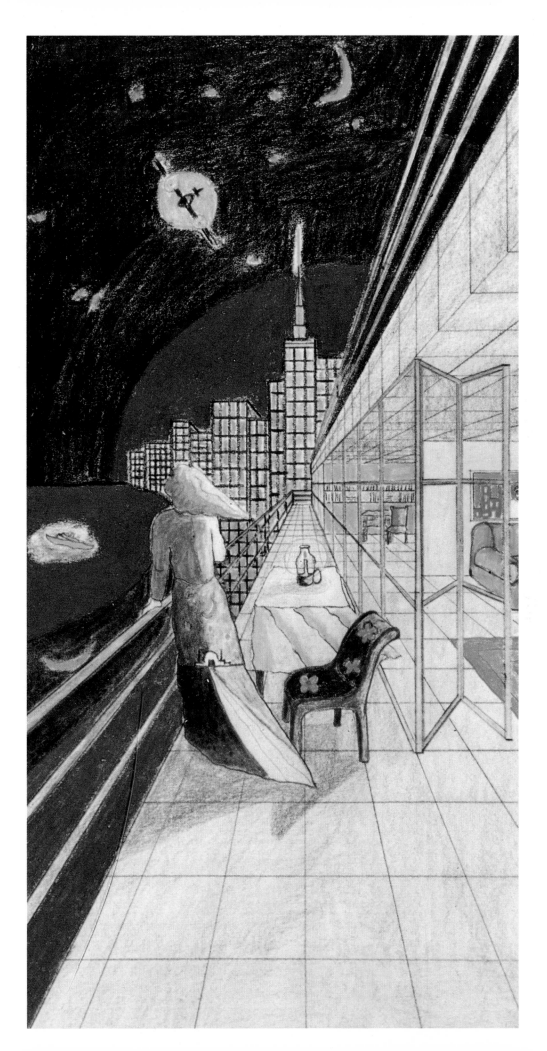

Nigel Coates

Nigel Coates graduated from the Architectural Association in 1974 and returned there in 1976 to serve as a Unit Master until 1986. In 1983 he formed **NATO** (Narrative Architecture Today) with students from his unit. Its philosophy was to create an architectural experience based on a poetic and pop-cultural interpretation of the urban centre, and to further these aims, **NATO** produced its own magazine and exhibited its projects in Britain and the United States. After receiving his first commission from Japan, Coates joined in partnership with Doug Branson to form Branson Coates Architecture in 1985. At the time, Coates was among the first British designers to be courted and fêted in Japan. Indeed, his early and widely published interior schemes for the Metropole Restaurant, Bohemia Jazz Club and Café Bongo established him as the best-known British architect in Japan. As his international reputation grew, the practice completed its first new buildings; namely, the Arca di Noe restaurant in Sapporo and The Wall in Nishi Azabu, Tokyo. More recently, Coates's innovative and often highly controversial approach to architecture is evident in his newly realized buildings, a string of fashion shops in London, Arezzo and Tokyo, and the Taxim nightclub in Istanbul.

The early NATO projects and, indeed, all the subsequent Coates projects embody his belief that the permanence of our sterile and culturally deprived cities needs to be seriously challenged. Coates feels that rather than perpetuate an historically imposed order, architects and planners should adopt a more popular and responsive imagery for the city.

Coates's vision of a pleasure-orientated urban experience proposes the intervention of an electronic overlay of 'soft architecture', i.e., an intermediary tissue of truly malleable architecture that can be created and computer-choreographed by the user to be played out in 'cyberspace' – the space we inhabit when we 'walk' in the computer-generated world of virtual reality – using light, colour and sound. Using software that Coates calls 'Ecstacity', cities like London, Brussels and Tokyo could transcend their architectural anonymity and mediocrity to become continuous media events in a constant state of flux. To achieve this end, chosen buildings and monuments would survive a selective demolition programme in order to provide support for, and coexist with, an electronic infrastructure – a continuously shifting, adapting and updating 'telepresent' interface on which our needs and desires would be 'painted-in' holographically. By invading the space already partly occupied by city advertising, Ecstacity would provide a collage of instant events.

When communicating the Ecstacity concept, Coates employs animated computer graphics, electronic billboards (flashing three successive images on a timed display) and subtle layered drawings. It is the latter which are of interest here because both their creation and their perceptual viewing condition utilize a layering process that takes us close to the Ecstacity ideal.

LONDON 2060 AD (opposite)

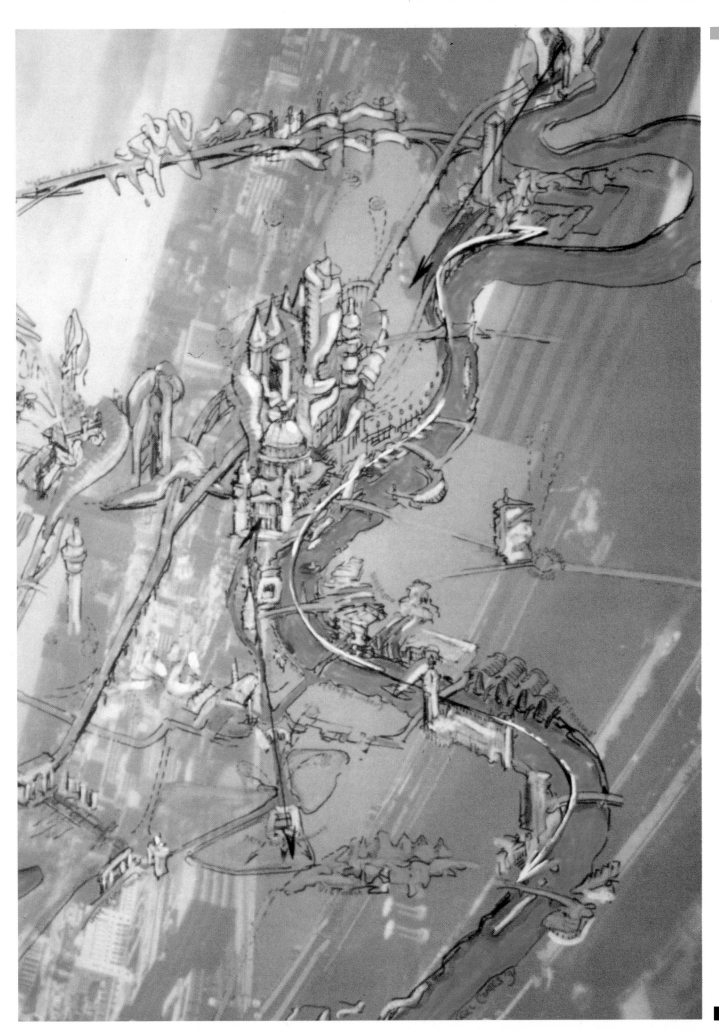

LONDON 2060 AD

Oil Pastel and Liquid Paper on Tracing Paper Laid Over a Colour Photograph, 42 x 59cm (16³/₄ x 23¹/₄in) (page 81)

When not painted directly on to paper using acrylic paint, ink and oil pastel, Coates's drawings and paintings are worked on translucent and transparent surfaces such as tracing paper and acetate. Despite the impression they give when published, the drawings are usually quite small in format. In some instances, however, individual images, such as the one illustrated here, have been enlarged photographically to immense proportions for exhibition purposes.

For Coates the line represents the essence of a drawing – everything beyond the line being introduced only to reinforce its meaning. For instance, this particular image began as an ink line drawing worked with a fine brush. Its fluidity and sensuous quality of line have become the hallmark of his work. The drawing was photocopied on to tracing paper before its line was extended using oil pastels in a typically Coatesian range of hues including ochre, umber, terracotta, pale grey-green and pale yellow, as well as three blues. The colours are used to pick out the River Thames and key city routes, to elaborate the outlines of buildings and monuments and, of course, to provide evidence of the Ecstacity intervention. The buildings and monuments are also picked out in white typewriter correction fluid, a medium found on the front and back of many of Coates's transparent drawings – especially those that do not use colour.

Once the drawing phase is completed, Coates seeks out colour photographs from magazines to work as an underlay for the line drawing. In this case he uses a single image, but some of his drawings utilize two or more magazine elements to form an underlay of ghosted colour. Obviously, the choice of photograph and its placement is dictated by the needs of the drawing but it is the layering of pictorial information in his drawings that is of interest because, in the overlay of a line drawing on a secondary system of coloured imagery, we find a technique which links to the principle of Ecstacity. For example, in this image the underlay is a laser-copied magazine photograph of an aerial view of a city. Apart from being chosen to reinforce and complement the structure of the line drawing, it also underpins the principle of Ecstacity.

Roger Ferri

Roger Ferri was considered to be one of the most important American designers of his generation. His tragic and untimely death in November 1991 meant that many of his innovative designs will never become realized buildings. After graduating from the Pratt Institute in 1972, Ferri became vice-president and design principal of Welton Becket Associates in New York from 1984 to 1986. During this time he designed more than two billion dollars' worth of construction, including the Dai-Ichi Hotel in Tokyo. In 1987 he opened his own firm, Roger Ferri Architect.

One of Ferri's most widely published schemes is his unbuilt proposal for a 44-storey glass skyscraper for Manhattan, which includes a series of setbacks with huge gardens and rocky landscapes. It is the perfect distillation of his theories about the integration of nature and architecture in built forms.

His search for a new architectural language based on natural form, and his commitment to creating conceptual studies of buildings using innovative design techniques, led Ferri to explore collage, coloured pencil and, unusually in architectural representation, pastel-drawing techniques. Often rejected by architects as a messy colour medium, pastel in the hands of Ferri became a vibrant, lively means of communication. His pastel images comprise a successful combination of colour and line that is progressively built up into a web of colour striations, where each layer of colour reads through to those underneath. His unique graphics have been widely acclaimed, extensively exhibited and much published around the world.

HYPOSTYLE COURTYARD, Pedestrian City Project for the New York Museum of Modern Art, Perspective
Pastel Drawing, 112.5 x 113cm (44 x 44^1/$_2$in)

Hypostyle Courtyard (see page 85 for illustration) forms part of a series of drawings from Ferri's Pedestrian City project, commissioned by New York's Museum of Modern Art for its permanent collection. Ferri's decision to produce a richly detailed presentation drawing was governed by his intention to create a convincing illusion of this courtyard space, one that positions the spectator's eye 'inside', rather than 'outside', its imagined space.

The larger theme of the Pedestrian City project — an architecture in close harmony with nature — influenced the choice of the pastel medium, its colour palette and its application technique, for the presentation drawing. The use of

HYPOSTYLE COURTYARD, Details

1 After being pricked with a pin at key points, the photocopied perspective outline is placed face-up on the drawing paper. Its image is then transferred using the 'pounce' method.

2 The pastel rendering is achieved by means of diagonal strokes. The drawing is rendered in clean, individual strokes of colour to establish tonal structure.

3 In the shaded areas of the composition, colour vibration is increased by adding small touches of red into the yellow- and blue-greens of the carpet.

pastel enabled Ferri to create a range of red-blue, blue, blue-green and green colours, rendered by a quick application of diagonal strokes over a rough surface. The rendering conveys the same optical sensation as that of seeing a clear morning light.

The paper selected for this drawing is a high-quality, toned pH-neutral rag paper with a 'tooth' (texture) that grips and holds the pastel. The grey colour of the paper provides a tonal reference point from which the colour rendering can be worked, up, towards the highlights, and down, towards the darker accents of shade. On a white paper, the rendering surface is toned down first with a thin blue-grey or other watercolour wash. A watercolour-quality paper is used for the application of such washes.

A perspective outline of the courtyard is constructed by plotting the points of intersection of all the key structural elements in the composition. Since the tripartite arches above the courtyard are all curved elements, these points are not difficult to plot and describe. Once established, the preparatory drawing is then enlarged to the required size on a photocopier.

Next, the key points of intersection in the perspective are pinpricked on to the enlarged photocopy print before it is placed over, and lightly affixed to, the drawing paper. The points are then transferred to the drawing surface using the 'pounce' technique, that is, by dabbing graphite or pastel dust through the pinpricks on the overlay using a swab of cotton wool.

After removing the pounce overlay, the preparatory drawing is then developed using a hard, fine-point pencil. The drawing process involves the connection of the transferred pinpricks: development can be constantly monitored by standing back and, from the intended viewing distance, assessing perspective accuracy and compositional progress.

Prior to pastel rendering, the drawing paper is tacked or stapled securely to a rigid support and fixed on an easel. The easel is pitched slightly forward so that during the rendering stage, excess pastel dust falls free of the lower portion of the drawing area.

Fairly light strokes of pastel are used to begin rendering, so that the image develops in progressive layers of clarity and refinement, avoiding any premature filling-in of the surface tooth. The entire composition is blocked in first, working from middle tones to high tones, and from middle tones to dark tones. In order to lend brilliance to the pastel rendition of light and shade, colour is applied in diagonal strokes.

Since pastel is an opaque medium, depth and colour vitality are achieved by juxtaposing raw and unblended strokes of different colours. For example, sunlit areas of the rendering are achieved by using contrasting colours of similar tonal value that are found close to each other on the colour wheel. Conversely, shady areas, where a transparent depth quality is needed, are

HYPOSTYLE COURTYARD

reproduced by juxtaposing complementary colours, that is, colours found opposite one another on the colour wheel, such as the reds and greens used on the moss carpet here.

The use of commercial chemical fixatives has been avoided, since these can change the colour quality and tonal balance of a pastel drawing. The completed drawing was framed and glazed as soon as possible. A fillet was used to separate the pastel-covered surface from the protective glass (acrylic or Plexiglas glazing was avoided, as the surface of these materials attracts loose pastel dust).

VIEW FROM SUMMIT GARDEN, Looking South, Madison Square, New York
Photocollage, 14 x 7.5cm (5$\frac{1}{2}$ x 3in)

Another presentation technique favoured by Ferri was photocollage. This example is one of a collection of images used to communicate a new and unusual skyscraper design which displays an extensive landscape on one of its exterior walls – a continuous 'urban garden' vista on the west façade, accessible from every floor in the building. The photo collage technique was chosen in this instance because it is a medium that conveys a truly realistic image, allowing the viewer to see as close a visual representation of the finished building as possible, without the distraction that conventional drawing techniques present.

View from Summit Garden includes three graphic elements: a black-and-white photograph taken at an appropriate height from an existing skyscraper in the vicinity of the site; line drawing, and an old postcard depicting a scenic landscape. The latter element was included after a search through various collections of old postcards of characteristic New York landscapes revealed the appropriate backdrop for the 'urban garden' façade; it was a way of providing a sense of place for the building's main features. Preliminary sketches of the building's mass were used to match up suitable images; the final selection was a card depicting a gorge.

A sheet of tracing paper was placed over the site photograph, and a pencil line composition was developed on it. Once the composition was resolved, a silhouette of each of the constituent graphic elements is drawn on tracing paper. This functioned as a 'cartoon' or template.

The template was used as a guide for the trace-cutting of each element in the collage. In order to guide the cutting process precisely, each template was tacked to the face of the collage material with small spots of rubber cement.

In this collage, the second graphic element was used to represent a glimpse of the curtain wall of the skyscraper. This was cut to shape from smooth, high-quality paper and a coat of casein paint applied, to simulate green reflective glass. Once dry, the mullions were inked in before the element was carefully glued into its exact position on the base image, an elevated view of New York. Using the tracing-paper template as a guide, the required portion of the post-card was cut out and glued into position on the base image. This process was continued until the complete collage was assembled.

As part of Ferri's colour drawings for the Madison Square skyscraper project, this collage was quickly published in design journals around the world. His instant and global exposure resulted not only from the timely and dramatic projection of his theories of the integration of nature with architecture, but also from his ability to communicate his concepts clearly and in a convincing and persuasive manner. His skills in two-dimensional image-making existed simply as an extension of those in his architectural design.

VIEW FROM SUMMIT GARDEN, Looking South

Six years after gaining his diploma from the College of Applied Arts and Architecture in Prague, Jan Kaplicky moved to London. Following a four-year spell in several architectural firms he joined Piano & Rogers and then Foster Associates. Kaplicky founded Future Systems in 1979 with David

Jan Kaplicky
Future Systems

Nixon, and ten years later was joined in partnership by Amanda Levete. Before joining Future Systems, and after receiving her diploma from the Architectural Association, Levete had worked in the offices of Alsop & Lyall, YRM

Architects and Richard Rogers & Partners. The Future Systems projects have been widely published and exhibited and include their high-tech 'tents', the giant skyscraper called 'Coexistence' and the pod-like Green Building for the City of London. They are also known for their concept of a museum without walls – a competition design for the new Acropolis Museum in Athens, and the Chiswick Business Park gateway – a commissioned scheme to provide an urban 'marker'.

Future Systems is an unusual architectural firm in that it does not adapt easily to the idea of the traditional architects' practice. Its architecture is not of a type conceived from the well-worn paths of architectural precedent, nor does it conform to any recognizable movement. Rather, Future Systems draws its inspiration from the wealth of organic structures found in nature, together with those man-made shapes and forms that have withstood the test of time. It is from these sources that they have evolved an architectural language of form that challenges our Western perceptual conditioning to the right-angle. Indeed their projects carry names such as 'Peanut', 'Drop' and 'The Wrap' – terms that in each case describe the aerodynamic forms of enclosed environments which have been organically evolved. Earlier projects were set in the wilds of a natural landscape, but more recent schemes have entered the metropolis, a move that highlights the contrast between the streamlined contours of their architectural interventions and the backdrop of a cubic and familiar urbanism.

However, far from being 'futuristic' in a stylistic sense, their projects enlist an advanced technology merely as a means to an end and, in the words of Kaplicky, to allow 'for a celebration of technology beyond aesthetics'.

Indeed, Future Systems projects result from a thorough, down-to-earth research into efficiently manufactured building systems. Consequently, their architecture favours a new kind of building that is low-cost, efficient and sensitive to the global environmental crisis.

Intensely investigated and meticulously detailed, each project is entirely practical. This workability is often reflected in beautifully made working scale models, although more commonly their precise, hard-edged technical drawings are accompanied by scenic photocollages, the latter images reaching a

ACROPOLIS MUSEUM COMPETITION PROJECT

wide audience. Kaplicky uses the photocollage medium because modelmaking can, by comparison, be time-consuming and expensive. Furthermore, by achieving a high degree of realism, his photocollages offer a pictorial quality that can aid the understanding of the design intention and provide easy visual access for the layperson.

ACROPOLIS MUSEUM COMPETITION PROJECT
Photocollage, 84 x 59.5cm (33 x 23¹/₄in) (page 89)

The intention of this image is to demonstrate the direct and unimpeded visual link between an experience of the museum and the Acropolis. Like all Future Systems photocollages, this one begins with a photograph – in this case one taken from a vantage point on the Dionysus site. The photograph was processed as an A1-size colour print that would form the base material for the collage.

Next, the lightweight structure of the enveloping space frame is generated as a perspective line drawing on a computer. After the tiny shadows which occur at the intersections have been added with a pen, the computer print out is meticulously trace-cut to provide the outline of the structural net. This is then carefully glued into position on the face of the site photograph.

Three further pictorial elements are added: the edge of the gallery floor, a museum exhibit and a hint of reflection in the transparent skin. The glimpse of floor is simply drawn on paper and cut out. The exhibit is a marble sculpture taken from a postcard found at the British Museum. This is then mounted into the collage to appear as though it were suspended inside the space of the museum, thereby demonstrating the direct visual comparison between object and Acropolis. The reflections are introduced by using short strokes of white tempera paint. Together with clusters of dots to simulate fixings in the transparent panels, this simple device reminds us that, although apparently non-existent, there is a thin skin of transparent material between 'inside' and 'outside'.

The beauty of Kaplicky's photocollages is their utter simplicity and economy of means – qualities that pervade his architecture. It is the convincing projection of reality, however, that makes his refreshing vision of a modern architecture distinctly achievable.

Spiller Farmer

Neil Spiller and Laurie Farmer formed Spiller Farmer Architects in 1986. Having met as architectural students in London, they both went on, after qualifying, to study myth, religion and art at University College, London. With offices in London and the Slovak Republic, Farmer is Visiting Professor at the University of Bratislava while Spiller is Honorary Professor of the New Architects Group at the University of the Midlands in Birmingham. The practice is involved in a wide variety of design and has carried out master planning work for towns and cities which include Warsaw, St Helier and Bratislava. Their drawings have been published and exhibited in the United Kingdom, Central and Western Europe and Japan, while a book of their work, *Burning Whiteness, Plump Black Lines*, was published in 1990.

Spiller Farmer projects are concerned with a personal exploration of graphic marks and techniques. The resultant vision is a display of architectural pyrotechnics – explosive drawings and collages that are rich in content, full of surprise and endlessly varied. Spiller Farmer describe their drawings as 'interstitials' – images that exist between art and architecture – and explain them thus:

'Drawing is a means of graphically exploring ideas in a non-specific way. Being a malleable medium, drawing influences the architectural conception. Drawing also allows the architect to experience the fears and ecstasies of the painter; to confront a blank canvas or paper is an act of violence, a denying of whiteness – the first mark being feared both by the surface and the artist alike. The result of this activity is a drawn 'hypertext', i.e., a drawing where the whole is less important than the creative process that produced it. Such drawings reflect a personal cartography, a map of intentions in the quest for creative identity. The drawing represents a mystic sea ready to be charted; the beginning of an architecture that is true.'

Preferring their drawings to evolve as spontaneous images, most of Spiller Farmer's graphics begin, unusually for architects, without any preparatory guidelines. Another unusual aspect of their working method is the fact that, being based in London and Bratislava respectively, they work largely in isolation from each other, communicating through their drawings. Indeed, as David Rock, of the London-based Rock Townsend practice, describes, they are 'drawing twins'. Every drawing has one side prepared by Spiller and the other by Farmer. This dual approach to design through image-making is a technique used in the collage illustrated on page 92.

DISAPPEARING PARK: VALE OF TEARS, Composite Drawing
Mixed media on CS10 Graphic Board, 50 × 75cm (20 × 30in) (opposite)

This apparently complex and high-contrast collage was worked quickly on the face of an eight-pack pad of CS10 graphic board. The mixture of media includes Frisk masking film with its backing sheet, Humbrol gloss black spray paint and four colours (scarlet, cobalt blue, lemon and violet) of Buntlack graphic spray paint, together with various ink-drawn and existing elements, including photographs and prints.

The collage is the result of an initial, frenzied layering of texture, pattern and colour. Some of the basic colour shapes are sprayed directly into the collage, having had their edges masked with Frisk film. Others are first drawn in ink on paper and then sprayed with colour before being trace-cut and glued on to the graphic board format. Together with the blue, purple, red and yellow shapes, strips of black and black-splattered colour shapes are also added. Further elements are introduced, including line drawing worked directly on the collage and existing drawings, together with prints, photographs and a detail of an earlier Spiller drawing cut out from a book and mounted on the central red square.

The whole assembly is covered with a layer of Frisk film backing sheet. Before this is applied, its low-tack adhesive side is sprayed at random with black water-based paint, the waterproof nature of the adhesive creating a 'resist' effect, so causing the droplets of pigment to 'shrink' and separate into clusters of minute particles.

The next step sees the surface of the collage being 'attacked' with a sharp scalpel. Shapes cut into the face of the image to different depths are then peeled away to reveal hidden and unpredictable effects in the lower levels of the lamination. Finally, to complete the collage, the cut and peeled surface is enhanced by the addition of further ink-drawn and spray-coloured elements.

VISION OF THE CITY OF THE FUTURE, Milwaukee, USA, Composite Drawing
Rotring on Graphic Board, 1.8 × 1.2m 71 × 47in) (pages 94 and 95)

Feeding directly from their fascination with the accidental and the random, Spiller Farmer's rich and intricate graphics act as conduits for their unusual design approach. This triptych of large ink drawings for the proposed rejuvenation of a rundown section of Milwaukee into three distinct areas, 'Neighbourhood', 'Central Business District' and 'Suburban Fringe', epitomizes their highly individual architectural language. Produced at high speed, the drawings are worked with a Rotring Isograph technical pen using two line weights: 0.5mm and 2.0mm.

DISAPPEARING PARK: VALE OF TEARS, Details

Spiller Farmer visuals function as an experimental means of discovering architectural form through intent, accident and randomness.

1 The developing collage is completely superimposed with a Frisk film backing sheet after the film's adhesive side has been sprayed at random with water-based black spray paint. When dry, the resulting 'resist' effect becomes yet another graphic element in the collage.

2 At the final stage, the surface of the collage is 'attacked' with a scalpel. Selective areas and shapes are cut into and layers of the collage peeled away to reveal surprise effects and shapes at different levels of the lamination.

NEIGHBORHOOD AREA

RECREATION TOWERS Y2 15S

OFFICE TOWERS Y1 15-20S

LAND PIER Y2 recreation

LIGHT IND.

CANAL Y1

BRIDGE LINK Y1

CANAL

FACTORIES Y1 2S

ARTISTS QUARTER Y2 3S

RECREATION TOWER Y2 12S

MEDICAL UNIVERSITY Y1 15S

SERVICE POD

OFFICE ELEVATION Y1 20S

SERVICE CORE

BALCONYS

OFFICE SPACE

OFFICE PLAN

FACTORY PLAN Y1-2 2S

BRIDGE Y1

BRID

VISION OF THE CITY OF THE FUTURE: MILWAUKEE, USA (page 93)

CHITECTURAL ELEMENTS
erlaying elements to create sense
space
e of markers to order space - i.e.
dges, towers and piers
UCATION
hool building
rease in vocational training Part
vate funding

1. Drawbridge Moat Security
2. Spacial Variety Varying Degrees of Enclosure
3. Travel to Work via Canal
4. Adaptability- House as Reflection of Owner
5. House as 24 Hour Living Toy

PIER

HOTELS Y2 20S

FISHING PORT Y3

PIER

WINE BARS, APRES SKI

KI RUNS Y2

RESEARCH CONFERENCE FACILITY Y1 20S

OFFICES Y1

PARKLAND Y3

BRIDGES

SUBURBAN FRINGE

COURTYARD

ALL WEATHER ZONE

HOUSE SECTIONAL PERSPECTIVE

SITE PLAN

PLAN

STRUCTURE

HOUSING MODULES

HOUSING Y1-3 2S

BRIDGE

RIVER COURSES

CANAL

MAIL BOX

BRIDGE Y2

Daniel Libeskind

Daniel Libeskind was born in Poland and studied music in Israel before turning to architecture. His later design studies took him first to New York, where he received his first degree at The Cooper Union School of Architecture in 1970, and then to the University of Essex in England, where he gained a postgraduate degree in the History and Theory of Architecture in 1971. His work was represented in the Deconstructivist Architecture exhibition at New York's Museum of Modern Art in 1988 and this, together with his extensive writings and widely exhibited theoretical design projects, has won him international acclaim. His importance also stems from a series of prestigious teaching appointments, such as his Directorship of the Department of Architecture at the Cranbook Academy of Art from 1978-1985. Apart from his current positions, which include Distinguished Visiting Professor at the Danish Academy of Art, Copenhagen, and the Davenport Chair at Yale University, he is also Distinguished Visiting Professor at Harvard University, the Louis Sullivan Professor at the University of Illinois in Chicago and the Bannister Fletcher Professor at the University of London.

Libeskind's transformation from a visualizer of design concepts to an architect of realized buildings came as a result of his success in international competitions such as the 1987 Berlin 'City Edge', in which his was the winning entry. After winning the international competition for the 'Extension of the Berlin Museum with the Jewish Museum' in the following year, he moved his studio to that city.

Other current and realized projects include a permanent pavilion for the World's Greenery Fair in Osaka, 1990, the Berlin pavilion for SIME 92, the Grand Palais in Paris, 1992, an office block in Wiesbaden and an urban housing complex in Berlin. The latter two projects are both under construction.

Libeskind has described the use of traditional architectural drawings as the 'silent accomplices' of building design; that is, as mere technical adjuncts to the business of creating architecture. As such, they are far removed from any future reality, and have lost the qualities of exploration, invention and fantasy that often distinguished them in the past. For instance, in a conventional sense, architectural drawings describe and literally depict a building or its parts. In contrast, Libeskind's drawings reappraise this tradition, by exploring architecture from outside its conventions. To do this, he abandons accepted pictorial modes in favour of a language of spatial signs intended to be deciphered rather like a musical score. Such a 'score' is his 'Chamberworks', a suite of 28 images, one of which is illustrated opposite. Having no beginning and no end, this series of drawings comprises a set of fluctuating abstract graphic fields, with each image in the sequence tracing the route of his continually changing thinking process.

Libeskind's method of working seeks no permanent structure nor any architectural type. Indeed, he concludes that '. . . the result of this journey in search of the "essentials" undermines in the end the very premise of their existence'. However, what they do provide is stages in a world of infinite possibility. By employing signs, lines and accents, his drawings transcend the everyday function of architectural drawings to disclose a mutating and liberating abstract geometry.

'CITY EDGE' COMPETITION MODEL, Berlin
Wood and Mixed Media, Scale 1:200
(pages 98 and 99)

Libeskind's project for the Berlin 'City Edge' competition aims to create a new type of living for a future Berlin. He describes the city's old buildings and ancient vistas as being like 'memorable places and names found on maps. Each appears in a different colour on a different background, though any colour can be exchanged for another by a traveller whose destination is not found on the map.' Therefore, the model represents a journey into the substance of the city and of its architectural detail.

This glued, thin-skin lamination of found and printed papers on a wooden superstructure provides us with another unique example of architectural drawing. It is one that transforms a two-dimensional illusion, making it, albeit at a scale of 1:200, a physical reality. The resulting coexistence of pictorial, sculptural and textual events also involves a poetic dimension because, by including printed texts, this rich and three-dimensional collage takes us to the very origins of Deconstruction. Although central to the architectural work of Zaha Hadid, Peter Eisenman, Bernard Tschumi and Libeskind himself, Deconstruction was born in literature. Initially conceived by the contemporary French philosopher Jacques Derrida, Deconstruction is used to describe a method of reading in which conflicting textual meanings undermine any fixed interpretation.

CHAMBERWORKS, Ink on Mylar, paper size 80 x 120cm (31½ x 47in) (right)

One of a series of twenty-eight drawings, this image is worked on paper using the full gamut of technical pen stylus sizes. It is the result of a frenzied drawing activity, demanding much stylus cleaning in order to maintain the flow of ink. The drawing also represents the fusion of different line weights from fine to super-thick (the thickest lines being filled in), and different line types – from ruled to freehand and from continuous to broken. The resulting energy is generated by the juxtaposition of these different relationships and by the intensity of the spatial dynamic they define – a quality, albeit in black and white, that is reminiscent of the work of the Russian colour theorist, Vassily Kandinsky.

'CITY EDGE' COMPETITION MODEL, Berlin

By combining pictorial, literary and sculptural components, Libeskind's model creates a new dimension of architectural experience. The entire surface of his model is carefully glue-laminated with the words and images of found papers. These are used to differentiate between existing and proposed structures. For example, black text on white pages torn from Bibles and telephone directories denotes existing elements while the white-on-black of reversed prints of architectural drawings denotes the form and extent of his intervention. Differentiation between site and design is further emphasized by his technique used for the raked building he calls 'Cloud Prop'. In contrast to the more random collage technique used elsewhere for the urban context, this form receives strips of a reversed print that have been specially trimmed for the purpose, and then meticulously reassembled to create an ordered, directional pattern. Finally, a red is introduced to target key points and selected linear elements of his design. This brings an additional dynamic to the energy already generated by the dense figure-ground pattern through using an essentially monochromatic tonal system.

Michael Sorkin

Michael Sorkin is a New York-based architect, urbanist and writer. He graduated from Harvard and MIT in the early 1970s and is now principal of the Michael Sorkin Studio, which has in recent years undertaken numerous projects, both polemical and practical. They range from Utopian urban schemes to proposals for whole areas of New York, Berlin, Hamburg and Tokyo, and from individual buildings to domestic objects.

URBANAGRAM, Black-and-white Collage on Paper, 21.25 x 27.5cm (8¹/₂ x 11in)

In 1991 Sorkin's Beached Houses project for White House, Jamaica received a Progressive Architecture design award. In addition to running his own design practice, Sorkin is currently Professor of Architecture at Columbia University and The Cooper Union School of Architecture in New York. His most recent books include *Variations on a Theme Park*, an anthology on the modern American city, and *Exquisite Corpse*, a collection of essays about architecture, including many from *Village Voice* magazine, where he was architecture critic for ten years. Sorkin has described the familiar techniques of representation, such as the plan projection and the perspective, as embodying characteristic distortions resulting from the need to present in two dimensions, something that is intended to be three-dimensional. For instance, he considers the 'fudged dimensions' of perspective to be 'too hokey' and he dislikes the uniform angularity as well as the Modernist overtones associated with the axonometric projection, despite its consistent accuracy of scale.

Preferring the quality of information given by the plan, section and elevation, Sorkin has spent the last three years working on what he terms 'Urbanagrams'. These take the form of 'Analogue Relief Plans' (ARPs), that is large scale constructions using wood, paint, and in some cases, metal. Sorkin's assemblages are constructed with two aims. On the one hand, they represent his ideas about the design of cities; on the other, they explore a more malleable and a more potentially collaborative process of design representation. Although his constructions represent city plans, the analogy is intended to be informal. For instance, green-coloured areas in the ARPs represent green space, blue (or silver) represents water, and extruded areas denote built-up space. Other correspondences, however, are more tenuous. For example, although issues of near and far, dense and less dense are addressed by the ARPs, precise questions of shape, volume or dimension are not necessarily answered.

The ARPs are meant to represent an improvement on conventional modes of expressing urban planning strategies, which tend to be either too formally non-specific (as in land-use, zoning and parcel plans) or too specific (as in conventional architectural masterplans). In both these modes, future elaboration and the possibilities for fruitful collaboration are too restricted, whereas the Urbanagram offers a greater elasticity.

URBANAGRAM, Analogue Relief Plan (ARP)

Wood, Metal and Paint, 40 x 40cm (16 x 16in)

Like many of the experimental drawing techniques illustrated in this book, the Urbanagram questions traditional modes of graphic representation.

James Wines

James Wines is the co-founder (with Alison Sky) of SITE, the New York-based design group that has been engaged in the development of experimental architectural projects since 1970. After graduating from Syracuse University in 1955, Wines spent most of the next decade working as a sculptor in Rome. Since the formation of SITE, Wines's prodigious output of work and ideas has entered the public consciousness on an international level. Consequently he lectures extensively and exhibits his drawings and projects in the United States and abroad. Wines has also received many major awards including those from the Pulitzer Fund, the American Academy in Rome, the Ford Foundation, the Guggenheim Foundation, and the Graham Foundation for Advanced Studies in Fine Arts.

To most people SITE's work conjures up images of ruinous façades, apparently unfinished structures and animated elevations that slide, tumble and peel away. These projects commissioned in the early 1970s by the showroom catalogue retailer Best Products Co. Inc., however, represent only a single facet of the group's work and philosophy. Indeed, by the end of the 1970s, SITE's designs had turned to what was to become a recurrent and prophetic theme: an architecture as host to, or subjugated by, an invasion of natural flora. This fascination with making the function of a building connect humanity with nature placed Wines in the vanguard of environmental designers who not only make positive contributions to the architectural debate, but who also address the wider and more profound issues of ecology.

Wines describes his buildings and environments as 'filtering zones' for various kinds of information. Sometimes this information is in the form of architectural commentary, sometimes it comes from cultural and regional identity; in other circumstances it derives from existing, surrounding or 'borrowed' landscape. Whereas architects trained in the Modernist and Constructivist traditions tend to approach buildings as hermetic abstractions imposed on a situation, SITE thinks of them as a kind of membrane for absorbing or commenting on their context. In this way, their buildings are less about form and shape-making and more about narrative or, most

recently, about exploring connections with the natural environment. Wines describes his drawings as follows:

'The descriptive nature of architectural drawings has always been "about things", since it is an indication of ideas that will ultimately be translated into a physical structure. The intention is conceptual; but the result may or may not be finished artworks, depending on the intent of the author or subsequent critical assessment. For many designers, the drawing is only notational or illustrative. For others, it is an aesthetic end in itself and sometimes pursued to the point where the architect never feels compelled to build anything. Finally, there is the interpretative drawing with a purpose to explain the aesthetic and psychological "sense" of a project. This kind of graphic representation usually has an independent status as art, mainly because of its fusion of concept and technique. I believe it is this category that best describes my drawings for SITE. They are never meant to be seen as works detached from architectural delineation, but the use of media and page composition is primarily an endeavour to find the best way of communicating a project's sensibility or relation to its environment. Since all my drawings have narrative or psychological intentions, the uses of watercolour, ink wash and charcoal reflect a need to describe very elusive fragments of information. I am usually

METAMORPHOSIS PROJECT, GARDEN SHOWROOM – TERRARIUM, Alternative Elevation, California, USA
Pen and Ink on d'Arches Watercolour Paper, paper size 43 x 35.5cm (17 x 14in)

Worked in Mont Blanc fountain pen, this line drawing uses the full gamut of freehand hatching techniques, such as short and long flecks, dots and verticals and cross-hatching. The overall richness of the drawing surface brings an equality of emphasis both to the landscape and the building design, which helps to melt the architecture into its setting – one of the central aims of the project.

trying to suggest an evolutionary and ambiguous process in a design field traditionally felt to be determinate, objective, hard-edged and formal. Naturally, I do my share of hard-line drawings for conversion to construction documents; yet the purpose of most of the work has been to capture an ambient mood or identify a conceptual direction.

Although the primary purpose of my drawings is conceptual, I am not a paper architect. Every sketch and rendering is motivated by the intention to

PERPETUAL SAVINGS AND LOAN BANK, Elevation, South Dakota, USA. Charcoal and Ink Wash on d'Arches Watercolour Paper, paper size 35.5 x 30.5cm (14 x 12in)

This is a prime example of one of Wines's so-called murky drawings – a quality which, in this instance, results from dusty charcoal blending with the surface grain of the watercolour paper. Part drawn, part finger-smudged, the density of the charcoal application, while eradicating much of the ink line underdrawing, provides a deliberate contrast to the ink-washed pattern of brickwork on the bank's split façade. When drawn with the point, however, the charcoal is restricted to vertical strokes to provide a further contrast, this time with the horizontal format of Wines's panoramic view. This 'letter-box' format underlines another important aspect of his design intention at the drawing stage, i.e. of an architecture seen as an integral part of its setting.

build. Although a number of projects over the years have not been realized for the usual financial or bureaucratic reasons, I have never drawn a line that did not anticipate a finished structure.

Actually, I dislike the entire premiss of paper architecture because it so often produces seductive graphics, while avoiding the challenges of construction. A drawing for its own sake, no matter how justifiable aesthetically and intellectually, is a compromised endeavour. It limits audience involvement by confining a three-dimensional vision to a two-dimensional substitute. Paper architecture tends to entice, without enriching. It is theoretically attractive on one level, yet dogmatically instructive on the other. In built architecture, to the contrary, the viewer is allowed to contribute many levels of perception and participation that expand a structure's significance beyond anything the architect could possibly describe on paper. It is the presence of people and their unpredictable interpretations that brings out the most complex and intriguing meanings in the building arts. Drawings are, at best, a prelude to this experience'.

The objective of attempting to describe on paper much more than form and structure has always been characteristic of Wines's drawings. It stems from the fact that so many of SITE's commissions involve the integration of nature with architecture. The graphic techniques used to interpret these projects have become increasingly a part of his design vocabulary.

Most of Wines's drawings are developed out of layered graphic techniques (equivalent to the layering of references in the final built form). The underdrawing is often relatively precise, and descriptive of some archetypal structure; whereas the final renderings in line, ink washes and charcoal are full of allusion to architecture in a state of flux.

In retrospect, Wines realizes that his drawings have, instinctively, been changing to address environmental issues. There has been a reduction of linear clarity and an advancing murkiness of imagery (the rendering of vegetation encouraging amorphous graphic qualities), coupled with a decrease in the importance of architectural volume. Wines describes the early work of SITE as attracting some hostile critics, who often claimed that his firm was trying to destroy some of the sacred values of architecture. 'Now they might claim we are trying to get rid of it altogether. With the world's environment in grave peril, this doesn't seem like a bad idea. While the awareness of apocalyptic or Utopian choices becomes more universal, I expect that, as an artist/architect, I shall continue to try to capture aspects of this dialectic in my work. The drawings seem destined to become murkier and murkier; but, on the more optimistic side, with rays of luminosity as well.'

**ECOLOGY PAVILION AT SEVILLE WORLD EXPO
1992,** Watercolour on d'Arches Watercolour Paper,
62 x 39cm (24¹/₂ x 15¹/₂in)

This drawing was first worked in sepia ink using a
fine-nibbed Mont Blanc pen. Prior to drawing,
Wines first saturated the surface of the paper with a
clear matt acrylic medium to increase the flow of the
ensuing watercolour wash. This is applied to reduce
absorbency and to allow the washes to be built up
gradually, with each under-layer flowing easily into
the next. The primer also increases the luminosity
of colour and results in Wines's abbreviated,
notional style of rendering, suggesting those conditions
that are paramount in his work: allusion, irony and
humour. Wines's distinctive style of watercolour
painting results from blobs of liquid pigment being
'dropped in' to create a mosaic of pools on the
waterproofed paper surface. The pattern of the
colour pools is further emphasized by the slightly
darker drying edge and, of course, where one pool
of colour mixes with its neighbours.

Austrian Ettore Sottsass graduated from the Polytechnic University of Turin in 1939 and set up his own architecture and design studio in Milan in 1947. Since 1958 he has been Olivetti's chief design consultant and his other clients include Alessi, Knoll and Zanotta. Defying categorization, his experimental

Ettore Sottsass

approach to the design of ceramics, tableware and furniture has established him as one of the great mavericks of the international design world. In 1980 he founded Sottsass Associati, then a year later he set up the Memphis Group, which provided the vehicle for his audacious assault on mainstream Modernist thinking. Always rejecting established design tradition, Sottsass's architecture also draws upon unconventional sources. For example, his love of naive cultures,

Indian temples and Californian houses feeds a vast output of drawings depicting Utopian ideas. One of the most notable realizations of his design approach is the Wolf House, sited in glorious isolation in the rugged Rocky Mountain foothills of Colorado.

Sottsass has an obsessive approach to architectural drawings, which he describes as being motivated by both love and fear. His fear, which approaches panic, occurs the moment he faces a blank sheet of drawing paper. He describes it as similar to the feeling he had when he was about to leave for his first visit to the Far East when 'I was scared stiff and spent nights with my eyes open.'

His compulsion to draw comes from a fascination with drawing materials. Sottsass is a paper fanatic, collecting different types of drawing surfaces from all over the world. Together with a vast collection of drawing and colouring materials, they are stored in a cupboard. 'When I open its doors,' he explains, 'an inebriating, faintly chemical, vaguely exotic smell exudes.' This intoxicating aroma counteracts his fear. 'Perhaps my desire to do drawings comes out of that closet, along with those mysterious odours.'

PROJECT FOR A SMALL DESIGN GALLERY, Ravenna, Italy, Perspective Watercolour Drawing, 61 x 46cm (24 x 18in)

Sottsass produced this drawing quickly on one of his favourite papers, a handmade, heavy-duty cotton watercolour paper he imports from Pondicherry in India. Flat and variegated washes of Winsor & Newton watercolours comprising two blues, yellow, green and black are applied over a simply executed pencil guideline drawing.

Apart from the washes applied directly to the paper, his colour rendering involves two types of wet-in-wet application. For instance, the foreground floor plane and view of glazing through the apertures of the blue courtyard wall introduce a diluted colour wash into an initial wash of clean water. This gives both a crisp edge and an even wash. The second version of the technique applies strokes of one colour into a previously applied and still wet

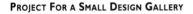

wash of another colour to cause a diffuse, feathering effect. The latter technique is reserved for central trees and shrubs and to register a stark contrast between natural and man-made forms.

Although the pencil under-drawing describes a one-point perspective view, it utilizes two vanishing points: one above normal eye level for the courtyard, and another below eye level for the middle-distance cube. Breaking with the rules of perspective, this device deliberately creates an almost childlike perception. Indeed, both the drawing and its rendering defy the 'professional' architectural drawing. Its directness and lack of any self-conscious technique reflect a vision unfettered by the norms and conventions of mainstream architectural graphics. What we learn from Sottsass's refreshing work is that media and their techniques are simply slaves to the vision of a design idea.

PROJECT FOR A SMALL DESIGN GALLERY

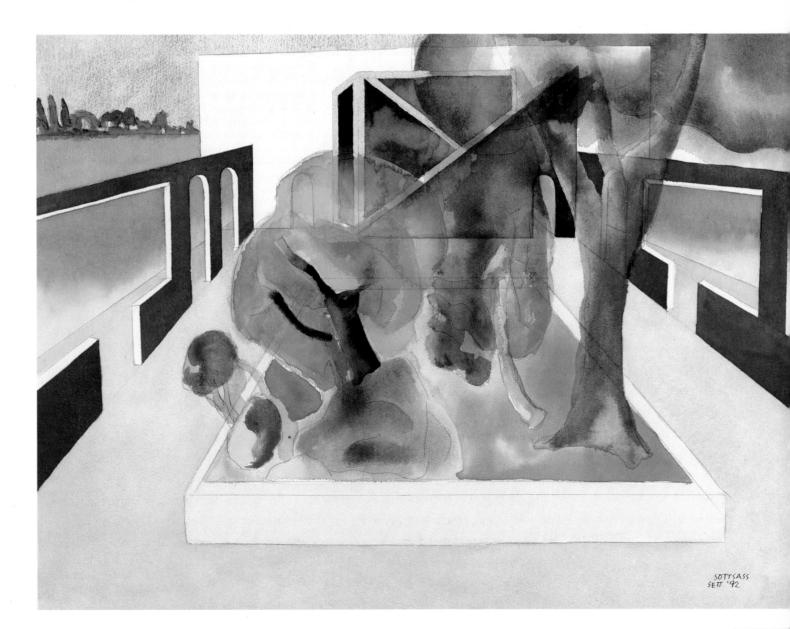

Steven Holl

Steven Holl is an honours graduate of the University of Washington, Seattle, and also studied in Rome in 1970. After post-graduate work at the Architectural Association in London in 1976, he established his practice in New York later the same year. The subsequent international interest in his highly sensitive design work has led to exhibitions at the Walker Art Center, Minneapolis, the Canadian Center for Architecture, Montreal, and the Museum of Modern Art, New York, which has purchased several of his drawings for its private collection. Among his most recent honours are the 1992 AIA (American Institute of Architects) Award for Excellence in Design for his 'Void Space, Hinged Space' housing and shops in Fukuoka, Japan, as well as the AIA Interiors Award for office renovations at D.E. Shaw & Co. in New York. His recent work also includes the Institute of Science building for the Cranbrook Educational Community in Detroit, and the Hybrid Building, combining shops, offices and condominiums, in Seaside, Florida.

The bulk of Holl's creative work looks at architectural design from an experiential standpoint. This phenomenological approach views every project as a distinct problem, with each design scheme treated as a separate effort, taking into consideration its relationship to site, climate and circumstance. 'Rather than have a single architectural signature that I simply move from city to city and from site to site.' Holl says, '. . . I strive to make connections to particular places. This approach is extremely challenging because, each time we start a new project, we begin again.'

Earlier in his career, Holl rendered his architectural drawings in pencil. But after finding that a large drawing could take up to a week to complete, he switched to the more immediate medium of watercolour – a medium with which his name is now clearly identified. Holl uses watercolour for two different types of image-making. The first involves a quasi-religious ritual, in which, every morning before leaving for the office, he will spend approximately an hour producing a small conceptual painting worked on a 12.5 x 17.5cm (5 x 7in) watercolour paper tablet. This regimen began in the early 1980s.

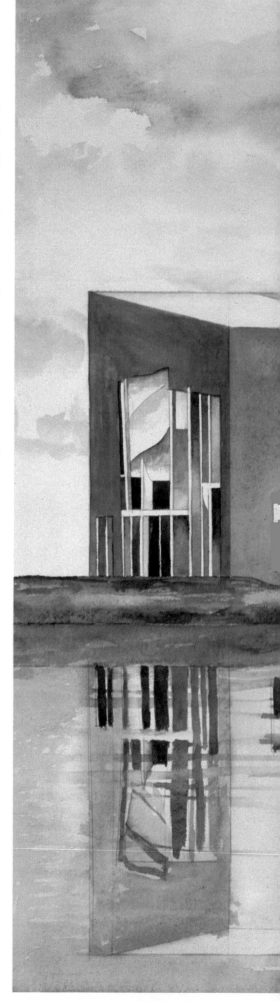

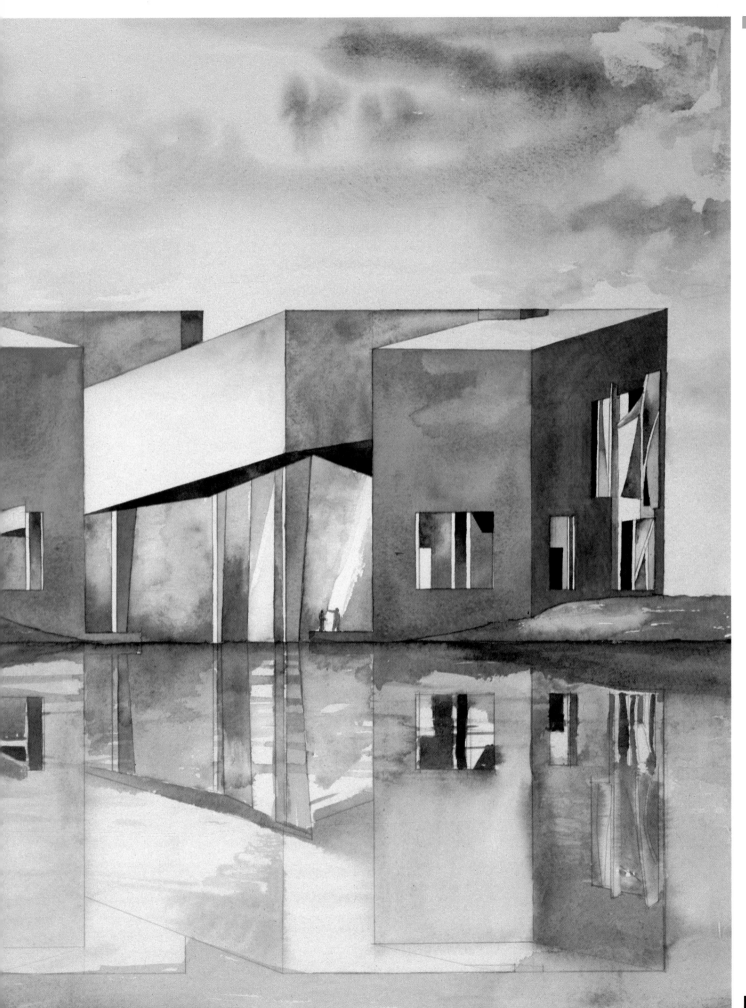

Three examples (above) of Holl's diminutive daily watercolour paintings. Filed and catalogued in Holl's office, they function as exploratory ideas that may be called upon for future projects.

It not only generates hundreds of such paintings each year, but also functions as an important means for exploring the conceptual side of his work and, as Holl describes, 'provides a means of bracketing my thought process'. Indeed, these diminutive abstractions, sometimes colourful, sometimes monochromatic, act as design overtures. Many ideas, for example his thematic exploration of the transformation of curving planes, re-emerge several years later in finished designs such as his handling of interior walls in the Cranbrook Institute of Science building.

Holl prefers a small format because it is easily portable. Together with his tiny set of Winsor & Newton watercolours, he can fit his work materials on to the flip-down tray of an aeroplane seat. He also works to this scale in the office – especially when testing radically different concepts as perspectives in relation to a current project. Finding the medium fast and easy to use, Holl revels in the ability of the wash to '. . . bring in light, to sense its changes, and to explore its effect on surfaces'.

PALAZZO DEL CINEMA, Venice Lido, Italy, Perspective
Watercolour on d'Arches Watercolour Paper, 54 x 51cm (21¼ x 20¼in)

The second type of architectural drawing used by Holl is his large and spontaneous watercolour perspectives. This example is a drawing that formed part of his invited entry to the Venice Biennale for a redesign of the Venice Film Festival building. The perspective construction for the drawing is worked initially in pencil by a member of his office, with reference to a scale model of the building. The resultant web of perspective lines is then transferred to a sheet of d'Arches watercolour paper, which is then pre-stretched and stapled on to a board support.

Holl then works on the drawing himself, using the fluidity of the watercolour medium to modify the design during the colour-rendering stage. He says, 'Although I really enjoy the act of making the painting, the truth is that it is not a mechanical activity but a further round in the process of design. When the transferred drawing comes to me, I change things directly in the painting, such as its perspective, its openings, its details, etc.' For Holl, the rendering stage is simply another design tool.

Holl's initial sequencing of space in all his projects is always worked exclusively through eye-level perspective – with orthographic drawings being employed much later. This approach is entirely in harmony with his phenomenological position. Indeed, *this* is the experiential connection, for, according to Holl, 'The concept that drives the design idea can be a larger intellectual idea, but the experiential dimension is one of an architecture understood from a shifting viewpoint that is approximately 5ft 6in [1.67m] off the ground.'

Richard Meier was one of the original New York group of Five Architects (also known as 'The Whites'). He received his architectural training at Cornell University and later established his office in New York City in 1963. Since that time, his private practice has designed residences, housing, medical facilities, museums and commercial buildings. Among these, his best known are: Twin Parks Northeast Housing, Smith House, Westbeth Artists' Housing, Douglas House, Bronx

Richard Meier

Development Center, Atheneum (all in New York); Hartford Seminary; High Museum of Art, Atlanta; and the Frankfurt Museum for Decorative Arts – all of which have won National Honor Awards from the American Institute of Architects. Meier has received many other awards for his work, including, in 1984, the Pritzker Architecture Prize (often referred to as the Nobel Prize for architecture), and the Royal Gold Medal from the Royal Institute of British Architects in 1989. In 1984, Meier was awarded the prestigious commission to design the Getty Center in Los Angeles. His office has also completed the headquarters for Canal + in Paris, the Museum of Contemporary Art in Barcelona, as well as office buildings in Munich, Basle, Luxembourg and Ulm.

Meier's architecture, often displaying nautical overtones, is preoccupied with the sculpting and eroding of elementary forms. His constant use of punctured and layered planes, with reflecting white surfaces to filter light into the inner complexities of their volumes, reflects an unrelenting search for purity. This integrity is also sensed in his drawings which, in turn, reflect powerful expressions of whiteness. Indeed, Meier describes whiteness as one of the main characteristics of his design work: 'I use it to clarify architectural concepts and heighten the power of visual form. It aids me in my primary occupation, which is the moulding of space and light – not abstracted space, not scaleless space, but space whose definition and order are related to nature and context, to human scale.'

The pervading sense of whiteness in Meier's drawings works at the opposite end of the scale to that exploited by the Pop artists in the 1960s, who used small amounts of white against a dense black background, in order to supercharge its contrast. In his case, the whiteness of the background is intensified by the sheer and unblemished precision of a black ink line. This meticulous approach to drafting is usually worked on Mylar paper with Rapidograph pens, using a full range of stylus sizes, from the smallest (0.13 mm) upwards. It has also become the hallmark of his widely-published and much-imitated drawing style; one that allows little room for tonal elaboration, relying instead on the established spatial convention of a continuous and a broken-line technique.

HIGH MUSEUM, Atlanta, Georgia, Elevation

Ink, Graphite Dust and Gouache on Pastel Paper, 89 x 53cm (35 x 21in)

This elevation began as a black outline drawing drafted in three line weights, the heaviest being reserved for the ground line. It was then photocopied on to a sheet of golden-brown Bainbridge pastel paper. The rendering is done in gouache, using a simple palette of white descending through a scale of two greys (a third mid-grey being used for shadows) and a descending scale of three mauves for use on the lower section of the façade.

Remarkably, the white and light grey areas of the elevation are introduced into the façade by meticulously painting each individual cladding module in turn to allow the printed line to show through. Meanwhile, the darkest areas of grey and the three mauves are applied as flat areas of paint – the line-defining modules being redrawn in ink over the gouache.

The modelling of the staircase is a superb example of delicate fine brushwork; the handrail being picked out in white and light grey to denote sunlit and shaded portions of its structure.

Both solid and transparent gouache washes are used to indicate shadows: those on opaque planes are painted in opaque colour; those on windows are introduced as a diluted grey wash. The rendering is completed with a graphite dust wash applied carefully with cotton wool along the skyline to simulate an overcast sky. This is dark enough to emphasize the silhouette of the building and light enough to pick up the pebbled texture of the paper's surface grain.

An important element found in many of Meier's elevations and perspective drawings is the famous collection of 'Meier trees' or, more accurately, 'Schinkel trees' (page 116). These are produced as photocopies, printed from engravings of the work of mid-nineteenth century neo-Classical architect Karl Friedrich Schinkel (a source also used by the late James Stirling for furniture in his perspectives). The photocopies are then resized to

HIGH MUSEUM, Detail

The painstaking care used in the rendering of Meier's elevation can be seen in a close scrutiny of its details. These, in turn, reveal delightfully rendered features. This internal staircase, seen through the glazing of the vertical circulation well, is delicately shown using fine brushwork over the photocopied line drawing. This kind of care and attention pervades the elevation drawing and gives it an overall sense of strength.

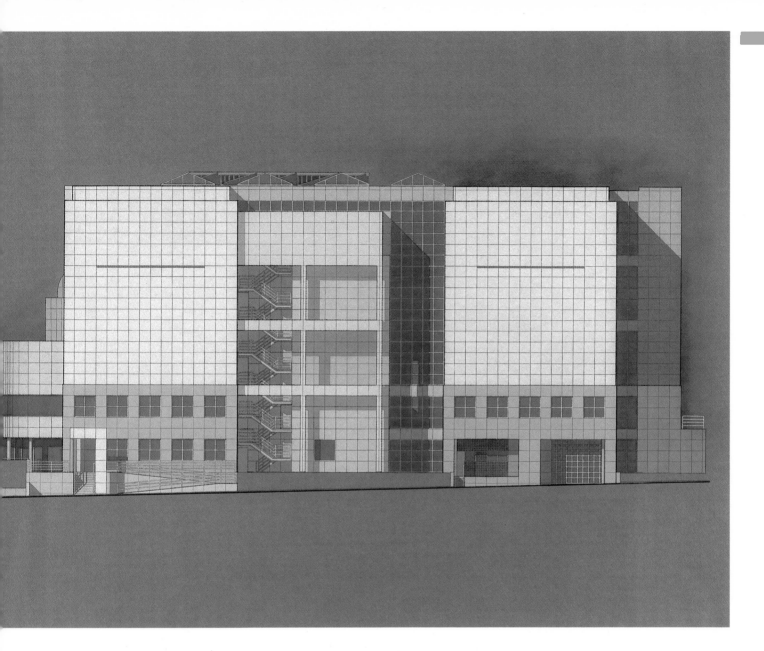

their required scale and glued directly on to the original drawing. Occasionally, the Schinkel trees will be joined by others that have been stippled by hand. A close examination of the way in which individual specimens and groups are arranged in Meier's drawings reveals several important compositional functions.

HIGH MUSEUM, Atlanta, Georgia

GARDEN PERSPECTIVE, MUSEUM OF DECORATIVE ART,
Frankfurt-am-Main, Germany
Ink and Photocopies on Mylar Paper, 91.5 x 91.5cm (36 x 36in)
(page 116)

The insertion of trees into the apparent three dimensions of a perspective can, in addition to tempering the starkness of a hard-line drawing, act to intensify the illusion of depth. For example, trees can emphasize the presence of space between picture plane and middle ground, and also imply space between the building design and its background.

GARDEN PERSPECTIVE, MUSEUM OF DECORATIVE ART, Frankfurt-am-Main, Germany

GARDEN PERSPECTIVE, Details

1 Meier's composition exploits graphic depth cues in its use of overlapping forms.

2 The view of the proposed building design is shown, as it would be viewed in reality, filtered and framed by middleground trees.

3 The positioning of trees between foreground and background is another means of visually 'stretching' the illusion of depth.

A second function of trees is their use as devices to frame or filter a composition. When viewing Meier's museum façade, the eye is offered a series of routes through the foreground space. By making the building less accessible visually, the demands made by the composition tend to create a more engaging viewing experience. Meanwhile, in defining these routes, the varying stature of individual trees exploits the concept of perspective depth. Indeed, even the overhanging foreground foliage and lower foreground shrubs seem to imply an extension of the space in the drawing between the viewer and the picture plane.

The best way of using trees, both in orthographics and perspectives, is as a compositional counterbalance. They should be included to provide context, act as a foil to the geometry of the drafted line and also as a compositional means of adjusting the picture's centre of gravity. This last aspect is important, because equally balanced or symmetrical images are of less interest to the eye than those which are counterbalanced. This accounts for the off-centre location of the main tree – a placement that avoids the common error of dead-centre elements that split a drawing into two halves. In this case, however, the tree exists as a tonal and physical extension of the right-hand mass of foliage against which the three discrete foliage elements on the left are counterbalanced. Finally, the fulcrum of this counterbalancing act is represented by the building design itself which, although partly disclosed, remains as the focal point of the drawing.

Zaha M. Hadid was born in Baghdad and received a degree in Mathematics from the Beirut American University in 1971. From 1972 until 1977 she studied at the London Architectural Association, where she was awarded the **AA** Diploma prize at the end of her studies. In 1979 Zaha Hadid started her own practice after working for a short time with the Office for Metropolitan Architecture (**OMA**). At first the focus of the practice was on research and experiment. Painting became an important testing field and medium of exploration. Architectural designs and plans were taken and elaborated through colour and the use of perspective. Since then the production of paintings, alongside more conventional architectural drawings, has become a vital element in the conception and completion of her projects and competitions.

Zaha Hadid

KURFÜRSTENDAMM, Berlin.

Hadid's first major project was the competition for the Irish Prime Minister's House in Dublin in 1980. Her first commission was an apartment conversion at 59 Eaton Place, London, which was awarded the 1982 Architectural Design Gold Medal for British Architecture.

In 1983, the practice won an international competition to design for The Peak in Hong Kong and gained international recognition. 1990 saw the realization of three projects, the refurbishment of the Monsoon Restaurant in Sapporo, the Osaka Folly, and the Musicvideo Pavilion at Groningen. In the same year the Vitra Furniture Factory invited Zaha Hadid to construct a fire station for the new factory.

Zaha Hadid's paintings range from dynamic figure-ground abstractions to a highly personal depiction of pictorial space. Many of her painted perspectives, particularly the aerial views, employ different sets of vanishing points within a single format, each controlling different zones of the painting. Consequently, their multi-angled viewpoints cause our perception to animate: at one moment we can be hovering in space; at another moment we are, seemingly, sweeping past at warp speed. Other paintings, such as the elevations, often simultaneously project several views of the same architectural form, sometimes employing a serial progression of drawings to rotate the image of the building through 180 degrees, in order to take our angle of vision full circuit.

Influenced more by the dynamism of a Russian Suprematist vision than by a fixed conventional perspective, Hadid's personal imagery opens up a dynamic spatial field. This is activated by her distinctive layering technique, involving a clearly defined and tensioned orchestration of angular and gently curving planes. The planes are subsequently coloured from an extensive palette which, on the one hand, can be modulated subtly by refined areas of earth colours or, on the other, be subjected to an intense luminosity, emanating from the contrast of pure colour.

Hadid's painting style has developed over many years, with different projects dictating different colour ranges and varying degrees of chromatic complexity. Relationships between building designs and their colour are usually explored in small preparatory colour studies. But, even when a painting has begun, the experiment continues in order to find a colour that will heighten the effect of a form. As part of the preparation process, a large number of acrylic paints are premixed for each painting. For a complex work, this can involve hundreds of different hues, each mix being stored carefully in colour-coded containers. Many of the colours used in earlier projects, such as The Peak competition paintings, are still in existence and are occasionally reused in new work.

The painting process begins with a pencil line drawing attached to a drawing board. The drawing is then transferred to a sheet of white, black or grey

KURFÜRSTENDAMM, Berlin
Chinese Ink and Acrylic on White Cartridge Paper, 84 x 119cm (33 x 47cm) (page 117)

The worm's-eye vantage point of Hadid's perspective increases the impact of the sweep and tilt of the curving façade – a dynamic that is further emphasized by the subtle tonal gradation.

THE PEAK, Hong Kong, Perspective
Acrylic on White Cartridge Paper Mounted on Linen,, 1.85 x 2.82m (6ft 1in x 9ft 3in)
(Main picture opposite, detail above)

The essential dynamic of Hadid's paintings originates in her animated and personal perspective. For example, in The Peak aerial view the ground plane is tilted, causing our normal perception of vertical forms to zoom and swerve.

BERLIN VICTORIA, Perspective

Acrylic on White Cartridge Paper Mounted on Linen,

2.53m x 1m (99$^{1}/_{2}$ x 39$^{1}/_{4}$in)

cartridge paper that has been pre-stretched with gum paper and taped on to a board. The initial painting stages may then be worked in acrylic paint, sketched in Chinese ink or washed with diluted acrylic. Before the outline drawing is transferred, however, some of the larger paintings are first covered with a background colour. Other drawings may be transferred on to the cartridge paper and be partly painted and washed to produce solid colour and faded effects. However, a recurrent and dramatic effect results from the

juxtaposition of shapes in solid colour with those blended from one colour to another. This transformation of hue within an architectural plane, together with hard-edged chromatic subdivisions and colour echoes in other planes, is one of the hallmarks of Hadid's paintings, intensifying the dynamism of her work.

Finished paintings are cut from the board before being heat-mounted on to canvas. Finally, the canvas is mounted on a stretcher-frame. If destined for exhibition, smaller paintings are framed simply.

In complete contrast to the traditional drawing-board approach to design, the painting medium is Hadid's means of previewing her architectural concepts; it is, she says, a way of 'exploring the work, of testing the colours, materials and light'. By functioning as the liberator of her inventive ideas and by conveying simultaneously factual information and the emotions that her buildings inspire, her paintings also transport us to the boundaries of a unique architectural experience.

BERLIN VICTORIA (pages 120 and 121), Details

1 Colour brings an added visual dynamic. For instance, the edges of angular forms are often defined sharply in a quickly fading white or bright colour, causing an illusion of the form to apparently surge forward through space.

2 A most dramatic feature of Hadid's paintings is the blending of one colour into another within one plane. Often employing complementary hues, the resulting contrast causes the colours to 'jump' and the form to energize.

William Alsop established the practice of Alsop and Lyall in 1981, eight years after graduating from the Architectural Association. His work enjoyed early exposure in the Centre Pompidou competition, and he went on to win other competitions, particularly in France and Germany. The practice's first UK

William Alsop

building commission was to design a Leisure Pool at Sheringham, Norfolk in 1987, which gained him international attention. There followed a series of major projects including the European Tower for Caen in France (in collaboration with Jean Nouvel, Massimiliano Fuksas and Otto Teidle) and the design of Hamburg's new Ferry Terminal building. It was the last of these commissions which brought Alsop into a working relationship with the Hamburg-based practice of Jan Störmer, with whom the firm is now associated. Consequently, Alsop and Störmer is one of today's leading European practices, with several important projects under its belt, including the Visitor Centre and Control Building for the Cardiff Bay Barrage and a competition-winning design for the prestigious Hôtel du Département building for the new government headquarters in Marseilles.

What is unusual about William Alsop is his approach to architectural design. His techniques derive not from the conventional paper trail of architectural orthographics, but from an initial investigation of ideas expressed in the form

HÔTEL DU DÉPARTEMENT, Scale Model

(page 124)

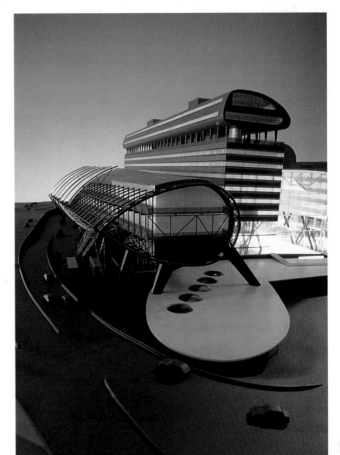

of paintings. This essentially private process, sometimes involving up to 30 or so paintings, begins with small abstract experiments worked in a sketchbook using watercolour, ink or acrylic paint. These early paintings explore the spirit of a new design idea in terms of its form, shape and colour. Then once the concept begins to formulate, it is developed on a larger scale, the size assuming huge proportions as the idea begins to consolidate.

Alsop has always been deeply interested in painting and has worked in this way for many years; the majority of his earlier projects were solely represented by a painted form. Compared with the restriction of traditionally drafted line drawings, he finds the process of painting a liberation. It provides him with a critical tool for the rapid flow of exploratory thoughts and images, free from any preoccupation with detail. In contrast with the work of other painter-architects, Alsop's canvases appear more abstract in their intent and more painterly in their execution. Indeed, much of his exciting and innovative architecture finds its origins in the fluency of his paintwork.

HOTEL DU DÉPARTEMENT, Marseilles

Acrylic on Canvas, 1.84 x 1.22m (72½ x 48in)

Alsop's architectural design ideas germinate amid the spontaneous application of strokes, splashes and dribbles in liquid acrylic pigment. What is most striking, however, is the similarity between the colours and shapes found in his large generative paintings and their subsequent reappearance in the development of commissioned buildings.

Usually worked on canvas or Mylar, Alsop's paintings are quickly created with a brush, palette knife and acrylic stick (available only in the United States). The spontaneity of Alsop's technique involves an interplay of thickly applied impasto, glazes of transparent wash and a deliberate dribbling of colour. Often a painting is as much taken up with his exploitation of the acrylic medium for its own sake as it is with any recognizable architecture. But within the sweeps of paint, the enigmatic geometry of his forms and the obvious celebration of colour, lie the seeds of an emerging architecture — many of these qualities survive through to the finished building.

Acrylic paints are compatible with a wide variety of surfaces, such as canvas, hardboard and paper, and are simpler to use than other media, particularly at the initial stages of painting. Before proceeding, it is essential to prepare the painting surface with two or three coats of primer. An acrylic primer is used for this purpose, as other primers will not bind sufficiently well with acrylic paint.

Although having little in common with oil paints, watercolour or gouache, the acrylic medium embodies all their advantages. Acrylic paint diluted with water is a fast-drying medium, but the drying rapidity can be slowed down by adding a few drops of retarder during the mixing process on the palette. The beauty of the medium is its flexibility, however. For example, it is capable of producing superb transparent washes, or glazes, and can also be used undiluted to achieve dense and opaque areas of impasto colour. Indeed, these are the exact characteristics that Alsop exploits so well in his large paintings.

Mike Webb

During the early 1960s Mike Webb was an active member of the influential Archigram group which comprised, among others, Peter Cook, Dennis Crompton, David Greene and Ron Herron. Earlier, while he was an architectural student at the Regent Street Polytechnic (now the University of Westminster), Webb's design work was already attracting attention. For instance, one of his published schemes incurred the wrath of Nikolaus Pevsner, who described his work as looking like 'exposed bowels'; a reaction which, as if in anticipation of the high-technology architecture that was to follow in the 1970s, was to cause the term 'bowelism' to enter the architectural vocabulary. Contemporaneous with Cedric Price's revolutionary Fun Palace of 1961 is another of Webb's student projects, the notorious Sin Palace design, his 'failed' but widely published thesis project for an entertainment centre. In 1965 Webb moved to the United States and began teaching at the Virginia Polytechnic Institute. He now lives and works in New York City, where he teaches at The Cooper Union School of Architecture and at Columbia University.

Webb's current design work pursues several issues, including his study of the relationship between the limitations of classical perspective and our visual perception. His interest, however, lies beyond his ability to simulate, albeit inaccurately in perceptual terms, a working image of reality. Rather than produce an image that remains coherent only when coordinated around a fixed centre of vision, Webb's drawings explore instead the geometry of what happens when we move to the edge of this visual field and, indeed, outside its limits. To do this, his drawings involve a second station point, or viewing stance, that is positioned away from that of a constructed perspective view. The result is an alternative view experienced from outside the cone of vision.

Webb's creations not only question the role of linear perspective in architectural design, but also offer their own world of infinite distortion, in which the ordinary assumes new and fantastic appearances. Within this geometry, the aesthetics of architectural form become insignificant. As he explains, ' In terms of our image of it, even a humble tin shed becomes something that can encompass half the earth. Therefore, the object becomes unimportant. What is important is the way that we interpret it; the way that we distort it in our mind. That is what I find so interesting.'

AERIAL VIEW, REGATTA COURSE AT HENLEY-ON-THAMES:
Horizontal Section Through a Perspective Cone of Vision Enclosing a
Volume of Sky, Water and Land (opposite)
Oil paint on Gessoed Schöllerhammer Board, 70 x 100cm (28 x 40in)

The luminous quality of Webb's colour rendering results from layer upon
layer of painstakingly applied and progressively diluted oil paint washes.
Slightly thicker initial under-layers of pigment give way to ever more
diluted versions until each colour just perceptibly modifies the one
below. This technique uses oil paint rather like watercolour but, to
achieve the desired effects of luminosity or diffusion, some areas of
Webb's rendering are the result of between 20 and 30 wash applications.
The washes are applied using a small piece of sponge taped on to the
point of a scalpel blade. The precise shape of each application is
controlled by Frisk film mask, successive layers of colour being dabbed or
'brushed' on to the artwork after the previous one has dried.

Selection of Nine Vertical Sections (out of a
possible 128) Each Radiating From Point 0
(where observer stands) Located at the
Vertex of the Cone.

The areas shaded black represent a solidified
sky, as seen on a summer's day, with
dangerously high ozone readings. Since only
that which can be seen by the observer is
included, any object in the landscape within
the cone of vision will cast a white shadow,
which may pierce through the plane of the
horizontal sectional cut.

S = Section

L = Left

R = Right

Thom Mayne
Morphosis

Thom Mayne received his Master of Architecture degree from the Harvard Graduate School of Design in 1978. Six years previously he was one of six founding members of SCI-Arc (Southern California Institute of Architecture). He established Morphosis in 1975 with Jim Stafford and Michael Rotundi – the latter leaving in 1991 to start up his own firm. Based on the belief that design is a collective enterprise, Morphosis was founded with the objective of developing unique projects that resist specialization in any one building 'type'. By challenging the status quo, the subsequent work of Morphosis has created an architecture that is on the cutting edge of design, receiving dozens of international citations in the process. While maintaining an intense involvement in the practice, Mayne frequently lectures around the world. He was awarded the prestigious Eliot Noyes chair at Harvard in 1988 and, more recently, held the Eliel Saarinen chair at Yale.

THREE HOUSES, Composite Drawing
Ink on Mylar, 87.5 x 162.5cm (35 x 65in)

This drawing superimposes the plans of Morphosis for the Gonfianti Residence, Crawford Residence and Sixth Street House to create what writer George Rand has described as a '...combined "score". The result is a visual poem with its own unique rhythms, a novel set of visual accents, symmetries and asymmetries'.

In an article about the award-winning design for the Cedars Sinai Comprehensive Cancer Center in Los Angeles, Paul Goldberger of the New York Times describes the emergence of Morphosis as follows: 'If their beginnings suggested a trendy upward mobility, it has become clear for a while that these men (and women) are among the best architects of their generation; rigorous in their thinking, humane in their outlook. Their work, which relies heavily on assertive sculptural form, often executed in metal, is both sensual and abstract, highly geometric yet never the prisoner of dogma. For Morphosis, theory doesn't seem to come first; the reality of the architectural problem does.'

The work of Mayne and Morphosis, like that of Frank Gehry, explores an American West Coast aesthetic which, in reflecting the shifting, multifaceted culture of Los Angeles, operates outside mainsteam Modernist and post-Modernist traditions. The result is an apparently idiosyncratic architecture in which ordinary materials are combined and employed in unusual ways to create an experience that can be at once complex and economical, harmonious and ambiguous.

The architect Peter Cook has described the method of design used by Morphosis as being one of their unique features. It involves an

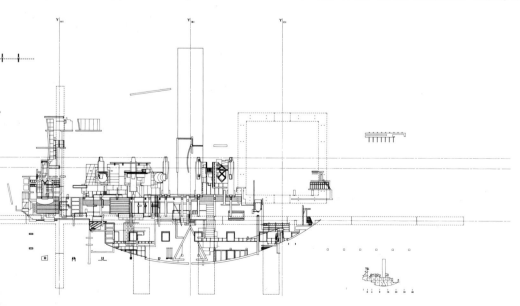

untraditional approach, in which Mayne and his team will, beyond the completion of a building, return to a reworking of its drawings and models. Seen as the source of inspiration for the evolution of new designs, these become the subject of a renewed process of analysis. It is from this retrospective means of pushing forward new design ideas, i.e., of creating and recreating, that the name 'Morphosis' is derived. An example of this process of what Morphosis calls 'reformation' is found in the Three Houses drawing opposite. This uses a grid to superimpose and transform the plans of three separate Morphosis house designs. Here the longitudinal and latitudinal grid co-ordinates serve to isolate segments – each of which is then transformed into a new existence as a three-dimensional object.

This process of overlaying, editing and transcribing from orthographics of existing designs is emblematic of Morphosis' work.

MTV

Graphite Paste and Mixed Media on Mylar, 77.5 x 90cm (31 x 36in)

Thom Mayne uses liquid graphite paste, an oil-based lacquer, as an experimental medium for his colour drawings. Before applying it, Mayne drains off excess oil to provide a more malleable pigment which can be used in conjunction with other paints. In its thicker state, the paste can be brushed on to or dragged with a palette knife over a variety of surfaces, such as paper, plastic film or wood. Furthermore, before it sets, Mayne can modify the paste by carving shapes or 'etching' lines with a knife, by making embossed impressions, or simply by pressing different materials, such as wire, into its surface. When dry, the paste can receive the colours of other paints or applied metallic leaf, or even a line drawing. This work was produced by Mayne, working alongside Dominique Jakob.

MTV (main image top, detail above)

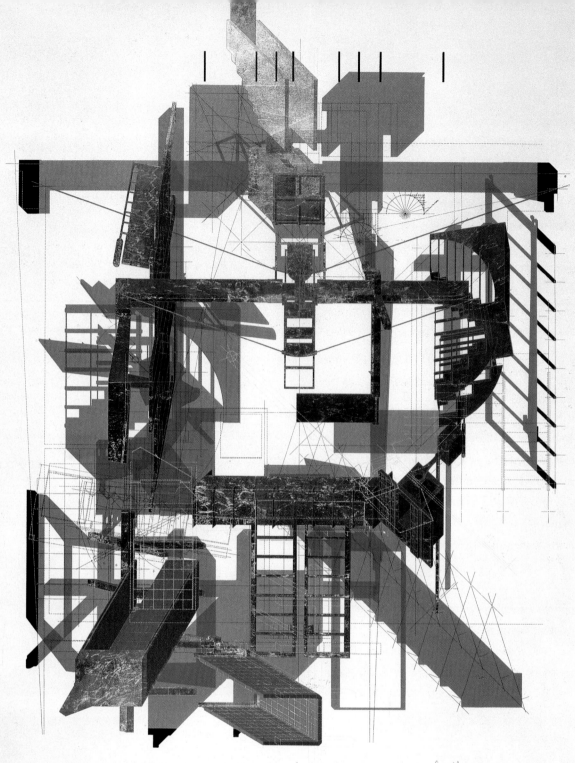

SIXTH STREET, Los Angeles, Composite Drawing

Serigraph Screen on D'Arches Paper, 75 x 100cm (30 x 40in)

This state-of-the-art serigraph print was produced by Mayne in close collaboration with Selwyn Ting and John Nichols Printmakers. It represents the photographic transformation of an original colour drawing into a high quality print. Each print in the edition is made unique by being embellished with gold leaf, which is glue-sized manually on to the print surface by Mayne.

Peter Eisenman is an outstanding American architect and educator. The recipient of numerous honours and awards, including a Guggenheim Fellowship and the Brunner Award of the American Academy of Arts and Letters, he founded his design practice in New York in 1980 after many years of teaching, writing and producing highly respected theoretical work. Eisenman's realized buildings include the acclaimed Wexner Center for the

Peter Eisenman

Visual Arts in Columbus, Ohio and his international competition-winning design for the Convention Center, also in Columbus. He is well known, too, for his Banyoles Olympic Hotel in Barcelona, and two headquarters buildings in Tokyo: one for the Kolzumi Sangyo Corporation and the other for the Nunotani Company. The two latter buildings received the National Honor Award from the AIA (American Institute of Architects) in 1991 and 1993 respectively.

Eisenman's reinvestigation of the formal nature of the architectural object is well documented in a number of his books as well as in numerous articles. This theoretical phase of his work saw a return to basic architectural principles and a redefinition of the interrelationships between line, plane and volume. An intensive study, it preoccupied Eisenman during much of the 1970s, and reflected his search for a personal architectural expression independent of functional needs and cultural symbolism. In rejecting the traditional practice of using graphics as a slave to architectural intent, his use of drawing directly engaged the *process* of design rather than its *end product*, so the final design was considered to be incidental to its evolution.

Consequently, in this early phase of his career, Eisenman's fascination with the act of design and with the techniques through which architectural form and space is fashioned became expressed in his now familiar serial drawings. These comprise systematic sequences of axonometric stills in a storyboard format, representing the stages of an unfolding design. By never using the distraction of perspective drawing and always avoiding any form of rendering, Eisenman focuses on the plan projection drawing, with the resulting axonometrics functioning as clinical 'mechanisms' which, when sequentially viewed, animate the process of design.

Eisenman's experimental period questions not only the traditional process of design and its mode of expression, but also our visual perception. For instance, his design for the House X project involves a series of stages in which an axonometric projection progressively breaks free from the confines of the drawing board, first to be detached as a flat and separate element, and then to extricate itself completely from the drawing as an independent and three-dimensional form.

HOUSE X MODEL, Axonometric Photograph

(right and below)

CARNEGIE-MELLON RESEARCH INSTITUTE,

Interior Perspective. Pantone on KC5 (photostat),
21.25 x 27.5cm (8¹/₂ x 11in) (opposite)

This interior perspective was first delineated in ink on Mylar film using a technical pen and three fine line weights. Although essentially a one-point perspective, its construction involves additional, adjunct vanishing points to plot the angle of the glass screen wall on the left and the curved displacement of columns and the tilted forms that occur between them. Once completed, the ink drawing was converted into a photostat print, that is, photographically transformed into a high-contrast copy negative and then printed on photographic paper. The print became the basis of a Pantone colour rendering, its selected complementary colour range involving cool soft purples and green-blues accented with a warm terracotta pink. Each piece of colour film was applied to the print as a rough-cut shape and then meticulously trimmed directly on the surface of the artwork – overlays of one subtle colour on another achieving the effect of shadows and the transparent quality of glazing. The perspective was given scale by the insertion of a cutout photocopy of a figure which was glued directly into the foreground area to occupy the implied space immediately forward of the picture, i.e., between the viewer and the picture plane.

Produced in 1978, this axonometric drawing literally projects its form as a model at 45 degrees to the picture plane. The resultant distortion is incoherent from all angles except that from a single, fixed and one-eyed viewpoint, located directly at its centre and in the angle of its projection. Consequently, only this singular intelligible view can be recorded with a camera.

Eisenman's experimental model is important, not only because it raises questions concerning our visual perception, but, as Deborah Nevins and Robert A.M. Stern observe in their book *The Architect's Eye*, it also re-examines and reverses the way we use pictorial illusion to make a flat surface appear as three-dimensional through the use of perspective. The graphic technique that has become associated with Eisenman's practice in

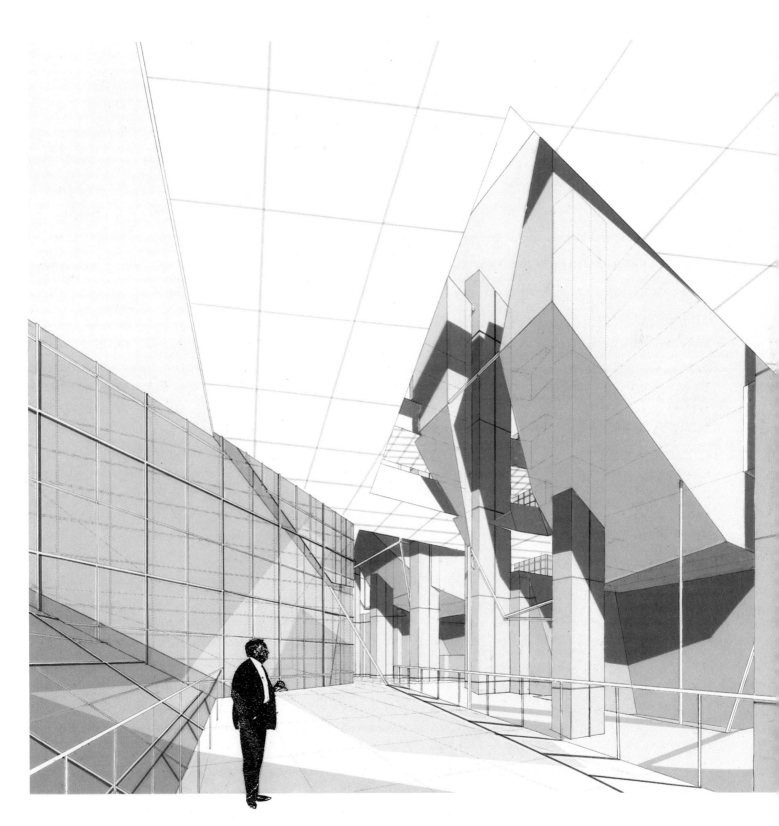

more recent years is Pantone colour film rendering. This is applied to orthographic and perspective outline drawings in the now-familiar subtle colour ranges that have followed his theoretical phase, in order to describe an architecture that is intended for construction.

CARNEGIE-MELLON RESEARCH INSTITUTE

Eva Jiricna

Eva Jiricna qualified as an engineer/architect at the University of Prague and later received her master's degree from the Academy of Fine Arts in the same city. She left her native Czechoslovakia in 1968 to live in London, where, following a spell as a designer at the Greater London Council and an ensuing association with the Louis de Soissons Partnership, she set up her own practice with David Hodges in 1980. Five years later, she acted as consultant to the Richard Rogers Partnership and received commissions from them to create interior packages, including some for the Lloyds Headquarters Building. Later, after winning a commission to refurbish the Way In department for Harrods in 1984, she founded Jiricna Kerr Associates. Eva Jiricna Architects was formed in 1986 and has a rapidly growing reputation based on Jiricna's interiors for Joseph, Legends, and Joan & David, as well as retail systems for Vitra GmbH and many award-winning competition designs.

Jiricna's design work, derived from a Modernist philosophy, is well known for its innovative and stylish approach. Her meticulous handling of detail, her creative use of light and reflection to create illusions of space, and her elegant engineering solutions to an often prosaic feature – exemplified in the celebrated glass and steel staircases for Joseph and Joan & David – are all hallmarks of her work. A most noteworthy feature of her designs is the way she integrates industrial materials and components into her interior design. Industrial clamps, tubing and wiring find their way into showroom, office and restaurant alike, to be transformed into a stylistic expression that is uniquely Jiricna's. This form of expression however, emanates from a finely tuned design approach which, in reflecting her intense interest in function and practicality, expresses her firm belief that function creates its own aesthetic.

The design process usually involves a team effort. It begins around a table with Jiricna and her team of architects and engineers, and when necessary, co-opted consultants. Within this forum, each design problem is discussed and sketched communally in a preliminary search for an overall language of design. Even at this initial stage though, internal components such as staircases are simultaneously considered, to decide the way in which they should be detailed and constructed so as to relate to other interior elements. These components are seen as fundamental to the overall design, and their consideration at an early stage is therefore vital.

Throughout the developmental design stages, Jiricna draws exclusively with her favourite disposable pen, a Nikko 0.2 fine point fibre-tipped pen. Always drawn in blue ink, these drawings (left) have become her trademark. Her generative drawings also disclose another skill, which is that of being able to sketch exactly to scale. She is able to switch graphically from 1:20 to 1:50 to full-scale with apparent ease.

CONCEPT DRAWING, Fibre-tipped Pen on Tracing Paper, 42 x 30cm (16½ x 11¾in)

IMAGE OF BRITAIN COMPETITION, Elevation

Pantone Film on Reverse Print,

42 × 59cm (16¹/₂ × 23¹/₄in) (page 136)

This is one of a series of drawings that won first prize for Jiricna in the Image of Britain ideas competition. Influenced by earlier Archigram collages, it describes her design for a tourist tower in a corner site of London's Trafalgar Square, comprising a restaurant, an airship terminal and an information centre, complete with audio-visual projection.

Her technique for this image involves two stages. The first one is the production of a line drawing worked in technical pen on polyester film to delineate the tower structure and background trees. The drawing is then embellished with a gradation of Letratone (to describe the curvature of the access points at the base), and extended with a found photograph of an airship and photographs of two existing façades. These latter images are resized on a photocopier before being trimmed and glued directly into the drawing.

The second stage is for the drawing to be photographed commercially for its conversion into a negative and subsequent reproduction as a reverse print. The resulting white-on-black photographic print provides the basis for the colour rendering. Colour is applied in five basic hues in the form of Pantone film. Rough-cut pieces are attached directly to the surface of the artwork before being carefully trimmed with a scalpel.

As with all such laminated artwork, the final image provides a seamless illusion once it has been colour photocopied, rephotographed or published – any joins becoming lost in the second-stage reproduction technique.

Although this drawing owes a belated debt to the collages of the Archigram group, its technique has been personalized by Jiricna. For example, its visual strength emanates from its technical precision, simplicity of composition and the intensification of a basic hue range as seen against black. By providing a night view of her elevation (night-time orthographics are comparatively rare in architectural drawing), she has made the structure appear to glow in the dark. Her colours respond to a fundamental complementary scheme involving blues and yellows, an additional red being introduced to draw our view upward to the top of the tourist tower and, of course, to the arrival of the airship.

IMAGE OF BRITAIN COMPETITION, Detail

The achievement of the spheres clustered at the structure is worthy of note. All the lines on the spheres, together with their tone – the latter applied using Letratone dry transfer film – were applied to the original drawing. Then dark lines were added to the final print using a roll-dispensed thin silver self-adhesive tape.

IMAGE OF BRITAIN by Eva Jiricna (page 135)

The central focus of the research and design work of Bryan Avery concerns a consistent set of themes: technology, contextualism and perceptual experience. Unlike that of many of his contemporaries, however, Avery's approach to an architecture of high technology is not one that employs the ubiquitous production-line metaphor. Instead, it concentrates on a finely tuned version of technology which is both carefully crafted to fit well into its setting and fashioned to create a formal response that embodies

Bryan Avery

historical and everyday connections. These issues have preoccupied Avery ever since his studies at Leicester Polytechnic (1962-68) and Essex University (1960-70) and are addressed in each of his many and widely published projects and built works. His approach also led to the commission of his best known building – the Museum of the Moving Image on London's South Bank.

Avery's most ambitious attempt to integrate his deep concern for the application of an innovative technology to an architectural context, in a manner that reveals the widest range of perceptual references, is exemplified by his Unesco award-winning design for the Advanced Technology Housing. Developed thematically over the last ten years, this ongoing project seeks to evolve new solutions for housing communities in urban centres, in the suburbs and in villages. In this project Avery steers a high-tech architecture in a new direction, that is, between a glib machine wizardry on the one hand and a pastiche of a classical or vernacular revival on the other. For example, his design work for the urban Advanced Technology Housing reinterprets the best features of the traditional English terraced house, while drawing on new technology to refashion its function and redefine its form. Small-footprint room-sized modules are stacked as required and interlinked by means of a rapid-response voice-activated linear drive lift which is controlled by the household system's microprocessor.

ADVANCED TECHNOLOGY HOUSING, Isometric
Combined Positive and Negative Photographic Prints with Pantone Rendering, 69 x 138cm (27^1/$_2$ x 55^1/$_4$in) (page 138)

While Avery's proposals for the rural and suburban versions of his housing are communicated with ink line drawings, the graphic presentation of his solution for the Advanced Technology Housing is depicted in a large reversed photographic print of a drawing made at 1:50 scale. The original was first drafted as an isometric projection made in ink on tracing paper – the terrace being cross-sectioned to expose a cutaway view into a typical nine-room town house. The drawing was then photographically reversed by a commercial print shop to produce a white-on-black 'negative' print. This print then became the basis for the next graphic stage.

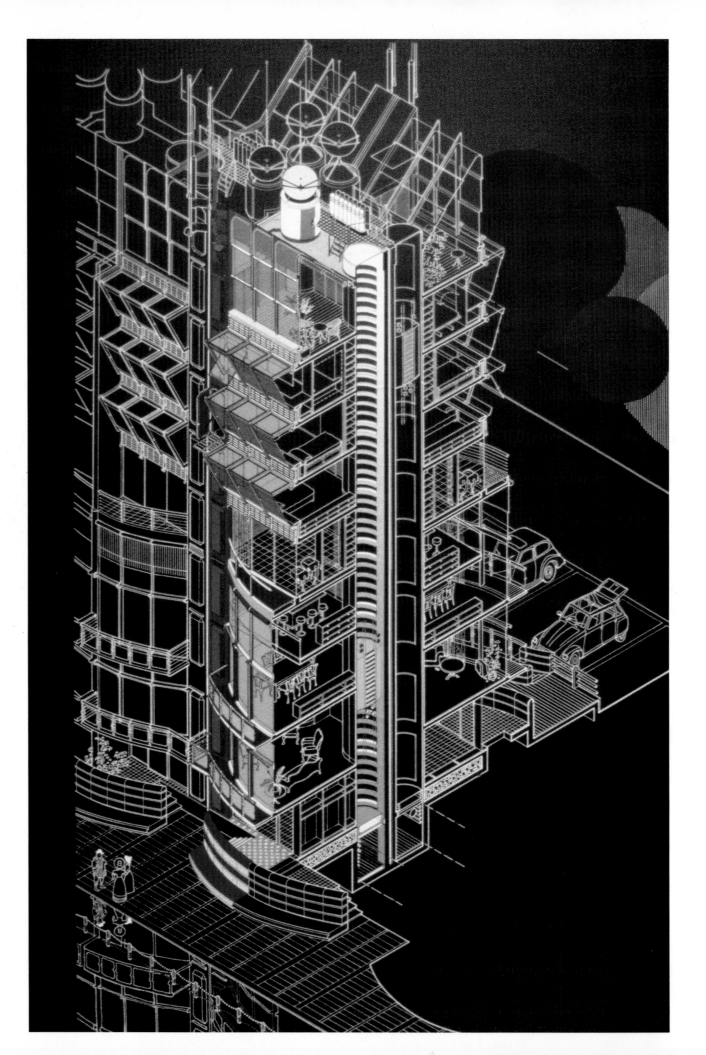

A second print was made from the original drawing, this time a 'positive', that is, black-on-white, print. From this, selected areas of the building – such as the vertical strip of glazing, part of the roof and ground plane and the exposed lift shaft – were carefully trace-cut, using a sharp scalpel, and removed. These elements were then introduced into their equivalent positions in the reversed print and carefully glued in place.

At this point Avery had achieved a combination positive-negative print that emphasized two viewing conditions. The negative print described the form and context of the building, while the positive print areas not only enhanced glimpses into the apartments but also emphasized simultaneously the duality of 'outside' and 'inside', together with the abstraction of the sectional slice.

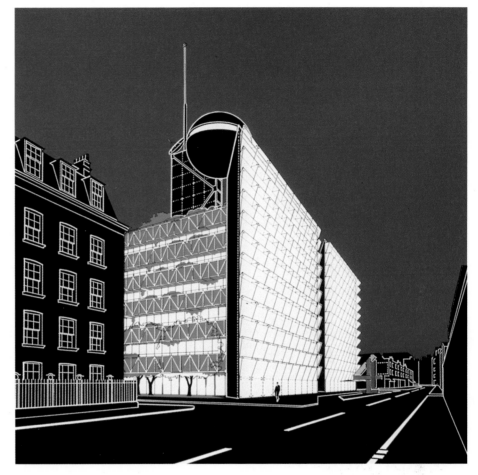

CHANNEL FOUR HEADQUARTERS, London

Like all of Avery's drawings, the graphic clarity of this perspective stems from his search for a medium that will communicate clearly the spirit of his design ideas. It involves the combined use of positive and negative photocopied prints, which are then rendered selectively with Pantone colour film.

In functioning as the centre of attention, the positive print areas then became the subject of a rendering stage using transparent Pantone colour film: the glazed sections were coloured in several grey tones while the opaque sections of the façade were coloured with two reds (terracotta and bright red) a pink, two blues (light and dark for shading), yellow and silver – the latter used to pick out balcony handrails.

The Pantone rendering stage also extends into the background, where three or four trees – simply shown as vertically hatched circles – were laminated with two reds and a yellow. While creating a counterbalance to the overall composition, it is this latter addition of colour that helps to connect visually the outside view with the inside view.

CHANNEL FOUR HEADQUARTERS BUILDING, London

Combined Positive and Negative Photographic Prints with Collage,
37 x 37cm (14²/₃ x 14²/₃in)

The same mix of positive and negative prints is again used by Avery in this perspective of his technologically innovative competition design for the Channel

ADVANCED TECHNOLOGY HOUSING (opposite)

ADVANCED TECHNOLOGY HOUSING, Silvertown

This incredibly simple but effective technique, involving a positive and negative photographic print (below), is useful when showing waterside elevations. First, a positive and a reversed print are made of the elevation.

After trimming along its waterline, the reversed print is then inverted and handed, and glued into position along the same waterline in the positive print.

To introduce some variation to the mirror image provided by the two prints, the yachts' reflections are scratched away from the copy negative before making the reversed print. The reflection is also 'doctored' with additional linework and white self-adhesive strips

Four building. In this case, the photographically reversed parent print receives three trace-cut and laminated elements from a positive print to highlight the two halves of planar glass wall on the main street elevation, and to differentiate this from the side elevation. This simply created but magnificent image is completed with flat areas of dry-transfer colour to enhance sky, foliage and company logo. Also, the addition of a marker yellow to the exposed white lines on the reversed print differentiates vertical surfaces from horizontal planes.

ADVANCED TECHNOLOGY HOUSING, SILVERTOWN, London,
Combined Positive and Negative Photographic Prints
67 × 33.5cm (26¹/₂ × 13in)

Another application of Avery's mixed-print technique is found in the more developed elevation of his Advanced Technology Housing project. Again, an ink delineation on tracing paper of the elevation was first photographically transformed into a positive and a negative print. The combined print was achieved by using the former as the main elevation view while the latter was trimmed along the waterline, inverted and handed, and attached on the same

datum. The resulting combined image provides an instant and convincing depiction of this riverside building together with its water reflection. An important detail in this elevation concerns the yachts. These were trace-cut to appear in the positive print then scratched away from a copy negative – hence their appearance in one print but not in the other.

Another important aspect of this mingling of two different prints is the implied space forward of the plane of the elevation. To produce this illusion, the eye infers the horizontal plane in which the reflection is seen and, in so doing, brings an added dimension of spatial meaning to the elevation.

VIDEO-VISCOM (MEDIATEQUE) BUILDING, Trafalgar Square, London
Photo-Drawing Montage, 42 x 42cm (16²/₃ x 16²/₃in) (page 142)

Avery's intention in this graphic presentation (overleaf) was the communication of a highly convincing perspective of his design for a media centre in the heart of London. To carry this out he introduced a perspective drawing of his design proposal into a photographic print of the site. Often used by designers who seek to test the impact of their schemes on sensitive urban contexts, this

VIDEO-VISCOM (MEDIATEQUE) BUILDING

This technique responds to a search for realism and inserts a rendered perspective drawing of a building design into an aerial photograph of its intended site.

The perspective plan grid is established with reference to the existing buildings seen in the photograph. Next, the building form is determined by extruding its corners vertically from the plan grid — its height being determined by reference to that of surrounding buildings.

Then the basic outline of the building is enlarged on a photocopier to a large format in order to introduce the graphite and ink rendering. The finished drawing is then photographed and printed to the scale of that in the aerial photograph. The image is trace-cut from the print and spray-mounted on to its site.

technique relies upon large prints that are composed from site photographs taken from several vantage points. These predict the best possible view of the design proposal. The best shot is selected as the parent image and processed into a large print. In this case, Avery used an aerial photograph acquired from an agency.

The print is covered with a sheet of tracing paper on which the area of the site is superimposed with a horizontal perspective grid — its vanishing points being plotted by reference to the co-ordinates implied by the existing buildings in the photograph. Once established, the grid is then extruded vertically and a preliminary sketch of the basic architectural form is made in pencil.

This basic delineation is next redrawn, this time in ink line, but at the same scale, so that the line thicknesses can be better balanced to the line densities within the photograph before being reduced on a photocopier back to the scale of the aerial print. Finally, a tonal fusion between the drawing and the photograph is introduced via a careful rendering in pencil and ink to achieve a matching density of shade and shadow. The perspective drawing is then trace-cut before being laminated into its precise position in the photograph.

When using this technique, two strategies can be considered once the ink outline drawing is achieved. The first simply introduces the ink drawing into the print with little attention paid to any pictorial fusion. In other words, the building design remains as an abstract contrast to the photographic quality of the print. Alternatively, as in the case of Avery's montage, the photographic quality of the print can be extended into the drawing. In this case, a sharp and contrasting print quality will be mirrored by an incisive shading technique. As part of this strategy the direction of photographed light and shadow will be extended into the drawing and the illusion increased by overlapping forms and cast shadows.

Whichever strategy is adopted, however, the potency of this technique is fully realized when the montage is rephotographed and transformed into the ultimate fusion of a second-stage print. This drawing-photograph combination has an obvious and striking function when used for communicating design ideas.

John Outram

John Outram graduated from the Architectural Association in 1965, and after a seven-year spell with the Greater London Council, founded John Outram Associates in 1973. His ensuing and widely published buildings include the Storm Water Pumping Station, Isle of Dogs, and the New House, Sussex, both of which established him as a designer deeply interested in a richer experience of architecture. Indeed, his masterly handling of the colour and surface texture of materials in the formation of an 'Arcadian space' has attracted widespread interest from the architectural fraternity and beyond. He has won several major awards for his work, including the Bayer Prize for Colour in Architecture, 1990, and the Worshipful Company of Bricklayers and Tilers Triennial Medal, 1990.

Outram's architecture is heavily symbolic and he often continues to explore the ideas beyond his buildings long after they are constructed. This retrospective approach to his design work started after the construction of, and widespread interest in, his first two buildings, when he was finding it difficult to explain their meaning. After two years of searching for a graphic means of conveying his ideas, he turned to words and stories. From these narratives he devised a catalogue of visual metaphors, a comic-strip of his buildings told in pictures. After selecting pertinent images from his storyboard and enlarging them in more detail, he found himself weaving more elaborate stories about them. The stories gradually coalesced into a longer and fictional narrative concerning the genesis of an idealized city. Consequently, Outram now has three distinct but interrelated elements in his work: writing, drawing, and designing and building architecture.

In contrast to architectural drawing in hindsight is Outram's Blackfriars Project, which represents a stunning graphic overture to a building's conception. The Blackfriars Court elevation is a huge image in which everything is made to appear real; its development involves a new graphic technique that engages a two-stage colour printing process using laser copy and bubble-jet reproduction – a technique which has never before been used on such an immense scale.

BLACKFRIARS COURT, Blackfriars Project, City of London, Elevation
Bubble-Jet Print, 2.2 x 1.9m (7ft 2¹/₂in x 6ft 3in)

The first stage in the production of this enormous image began with a 1:20 scale setting-out drawing which provided the dimensional framework for the compilation of the collage. Because this master drawing occupied fifteen A1 sheets, it was assembled and laid out on boards.

(continued on page 146)

BLACKFRIARS COURT, London

Photographs taken of existing buildings facing the site were resized on the colour photocopier to be used in the following way:

Areas of glass in the elevation drawing were carefully trace-cut and removed using a scalpel. The photocopies of the facing buildings were then trimmed along their skyline and face-mounted on to a background photocopy print of the sky. After covering the image with a sheet of thin tracing paper, the simulated reflection was inserted behind the window frame in the elevation, ready to be colour-copied as a second-stage print.

Using the anamorphic zoom facility on the Canon 500 photocopier, Outram reconstructs the illusion of a column. To do so he first draws and colour-renders a representative section as a flat pattern. This is then distorted successively along its short axis. When reassembled, the strips of column create a powerful and seamless illusion of the cylindrical form. To achieve the required length of the column, Outram simply rephotocopies the section of column in order to mass-produce the number required.

BLACKFRIARS COURT, Blackfriars Project,
City of London, Elevation

Comprising the equivalent of fifteen A1 [58 x
82.75cm (23¹/₂ x 33in)] Cibachrome prints,
Outram's enormous elevation in its final form was
exhibited at the 1991 Venice Biennale. The
preparatory collage was built up from small
fragments using a Canon 500 colour copier. It was
produced by a team working directly under the
guidance of Outram, and including Uma Mahadeva,
Elizabeth Gregory, Sally Mackay and Mazlina Noor.

The rendering phase came next, in which the various elements of the building facade were drawn in technical pen, rendered in coloured pencil and collaged into the master drawing. In the case of repetitive architectural elements, a representative portion was first drawn and fully rendered before being duplicated on Outram's Canon 500 colour copier. The resulting laser prints were then trimmed, joined together and laminated directly on to the developing collage. In this way, the building elevation was literally mass-produced, i.e., built up progressively in a component-by-component fashion – each fragment being delineated in ink on polyester film or plain paper, colour rendered, duplicated when necessary and then spray-mounted on to the image. The elevation was then further developed by the introduction of shadows. These were hand-rendered directly into the collage. Also added were the sky, colour-copied from an old engraving, and the images of existing buildings, figures and trees, etc., each trace-cut from specially taken photographs.

The final stage in the achievement of Outram's extraordinary elevation saw a further transformation, from its composite of laser-copied prints, to a same-size colour reproduction on a commercial bubble-jet printer. In other words, the image now passed from its thermal photocopy form to a more lively image provided by the digitized ink-jet print process. To achieve this, the collage was fully assembled on its 2.2 x 1.9m (7ft 2¹/₂in x 6ft 3in) baseboard before being cut jigsaw fashion into 15 A1 fragments – each mounted on backing sheets. Once reprinted, the bubble-jet images were finally mounted on a wooden baseboard and then heat-sealed and framed for exhibition in the Venice Biennale.

At the heart of this stunning image lies Outram's desire to document in a single drawing all the colour detail, and even the dirt, that would appear on a real building. In so doing, he achieves a new order of information, which he describes as 'hyper-realism'. Hyper-realism is his means of circumventing the inherent abstraction in drawing and a pitfall common in architectural design, when an architecture is designed to look good in graphic but looks awful in its built realization. He suggests that '. . . it's simply that people do not have a medium for previewing the real building. What this process provides, albeit without movement in real time, is a big image. Buildings are big and their designs need a big image in order to truly preview their impact.'

Bernard Tschumi studied architecture in his native Switzerland, where he graduated from the Federal Institute of Technology (ETH) in Zurich in 1969. Following two teaching engagements during the 1970s at London's Architectural Association, he founded Bernard Tschumi Architects in 1987, with offices in New York and Paris. He continued his teaching at various schools, including Professorships at Princeton University, New York's Cooper

Bernard Tschumi

Union School of Architecture and a Chair at Yale University. He is currently Dean of the Graduate School of Architecture, Planning and Preservation at Columbia University in New York. It is his consistent success in prestigious international competitions and widespread publication of his work, however, that have established Tschumi as one of today's most original and adventurous architects. From among his many award-winning projects, his most famous realized work is the ongoing series of 22 follies in the Parc de la Villette, Paris, and the Glass Video Gallery in Groningen, The Netherlands.

Tschumi feels that the nature of an international competition demands an intensive and highly specialized design and communication response. Therefore various inventive techniques have been devised in his office in order to give form to his ideas. These aim to provide a graphic vehicle which, in the face of competition from the larger international offices, and under pressure from submission deadlines, not only achieves unique and compelling images quickly and cheaply, but also imbues an often radical design concept with a strong sense of actuality. The results of this search for realism in graphics has led to the achievement of some distinctive and powerful images which are now firmly identified with his work and practice.

An essential tool for Tschumi's techniques is the Ricoh DS 320 photocopier, a highly sophisticated machine offering a digitized print technology. One of Tschumi's most compelling and much imitated techniques begins with a plan projection drawing that is produced 'live' on the machine – the photocopier is capable of being programmed to compress or extend axonometric projections from the plan. Indeed, to animate the perception of a design idea, Tschumi will sometimes spin off several orthographics from the same plan. The photocopy print is then camera-shot for a further transformation into a black-and-white print on RRC resin-coated paper. The final photographic print can sometimes result from an overlay of two different negatives.

The print is then airbrushed in colour, usually with a restricted palette comprising Steel Blue, Paine's Grey and particularly, Cali Red; the latter provides a familiar red, close to that found on the Marlboro cigarette pack and one that has become a distinctive Tschumi colour (page 150).

GLASS VIDEO GALLERY, GRONINGEN, The Netherlands
Photogram, 79 x 58.5cm (31 x 23in)

Another technique devised in Tschumi's office is the 'photogram', achieved by means of several reprographic stages being applied to a 35mm transparency taken of a scale model – in this case, constructed stage-set fashion to a scale of 1:50. The transparency is passed through a sequence of reprographic transformations, including its initial conversion into a 20 x 25cm (8 x 10in) Cibachrome print, which is then reduced on to vellum paper on the photocopier. The photocopy print is next reshot and resized, using a process

camera, to achieve an enlarged monochrome and continuous tone print. This final print is then coloured in selective flat areas with an airbrush.

Often misread as computer-generated images or even silkscreen prints, Tschumi's photograms provide a fascinating depiction of a design concept that is seemingly bathed in the light of aerial perspective. Discovered almost by accident, the process has a clear intention; each step in the transformation sequence reduces detail and softens hard edges in favour of a convincing sense of scale and existence. These qualities are often enhanced by small accidents in the process itself. For instance, incidental intrusions of light and objects in the original photograph and the effects of colour shifts – both within the process and in its ultimate reproduction in the architectural press – are used to provide a means of distancing any evidence of the creator in the ultimate image. This quest for pictorial anonymity also extends to the airbrush rendering, where the introduction of immaculately flat and deadpan colour washes avoids the remotest trace of any consciously executed marks in the final representation.

Unique to Tschumi's work, the photogram also subtly shifts the standpoint of the viewer because, rather than viewing an architectural drawing, one is taking part in an entirely plausible architectural event. Robert Young, the Chief Architect in Tschumi's New York office, describes the photogram as '. . . serving the idea of the design concept more than any other medium. It makes it possible, especially in the competition setting, for the architectural image to pop right off the page'. Furthermore, he describes the experiments with new technology in the search for an almost 'automatic' form of image-making as being ' . . against a Beaux Arts sensibility. Our drawings . . . emanate from a

MUSEUM BRIDGE, Centre of Plastic Contemporary Arts, Lausanne, Perspective

Airbrush on Photographic Paper,
58 x 79cm (23 x 31in)

The techniques used for Tschumi's extensively published and much imitated drawings are often misunderstood by an audience who misinterpret his photograms as computer-generated images. However, the machine-like impression of his graphics results from the transformation from one graphic form to another. In this case, a line drawing is photocopied on his Ricoh DS 320 machine before being camera-shot for its conversion into a high-quality glossy photographic print. Finally, the print is airbrushed with flat areas of selective colour.

contemporary academic thinking that addresses post-Structuralist issues and current social conditions, etc. Much of the idea of the elimination of evidence of authorship is expressed in our drawing'.

The search for graphic anonymity also involves the computer and the development of the 'Digigram', a digitized image with a grain created from pixels of colour. Although in one form it can appear as a plan projection and in another look like an elevation, the photogram is neither. Rather, it represents a new form of design and presentation tool that exists somewhere between the processes of drawing, modelmaking, printmaking and photography, while involving all four.

Cedric Price is undoubtedly one of the major forces in British architecture. Once a student at Cambridge University and at the Architectural Association in London, he taught part-time at the AA for six years from 1958 and founded Cedric Price Architects in 1960. Apart from a series of realized

Cedric Price

temporary structures, such as the 'Hair Tent' theatre in Rotterdam, his permanent buildings include private houses, the Inter-Action Centre in London, the British Transport Docks Board Computer Centre in Middlesex, a catering complex at Blackpool Zoo and his celebrated Aviary at London Zoo (designed with Frank Newby and Lord Snowdon). His seminally most significant building design remains unbuilt, however, despite being an icon of modern architecture in the minds of countless designers. It is the acclaimed and 'architecture-free' Fun Palace project of 1961 – a concept to which, to paraphrase Robin Middleton, much ensuing architectural thinking owes such a debt, and without which 'much of Archigram and Centre Pompidou would have been unthinkable'.

Price's enormous contribution to the architectural debate stems not only from his many realized works, but also from an endless flow of innovative ideas that consistently excite, influence and provoke his peers. As an *'agent provocateur'* Price has, in the words of James Gowan, 'done much to undermine orthodoxy and complacency by his heretical insistence on rethinking each problem, not necessarily in building terms'. The scale of these projects can range from a birdhouse to a city masterplan; their ingenuity ranging from, for example, his concept for the substitution of stereotyped educational buildings with mobile classrooms (his Potteries Thinkbelt project, which connects higher education to the railway network), to the Ducklands experiment – which was an invitation from the Hamburg city authority to establish a waterfowl nature reserve on disused docklands near the mouth of the River Elbe.

In describing his work, Price has identified a sequence of five drawing stages that form a creative loop in his presentations. 'In head' drawings is a term he uses to describe his embryonic ideograms, informed doodles and diagrams; 'in house' refers to those drawings used to communicate ideas and information between members of his design team. Drawings shown to clients, or publicly exhibited, represent the 'public/client' phase, while his 'in action' drawings are the operational graphics that monitor and convey the on-site building stage. Finally, when all the drawings are stored, they form a memory bank that provides Price not only with a 'permanent indulgence' but also feedback which he can reflect on, improve and use to inform the 'in head' phase of each new design cycle.

Being more concerned with *process* than with *style,* Price's drawings defy categorization. In other words, rather than display a preoccupation with the

FUN PALACE: FINAL SITE, Mixed Media on
Photograph, 67 x 34cm (26¹/₂ x 13¹/₂in)

The adaptation of reprographic images into analytical
and presentation drawings is typical of Price's work.
For instance, for this much publicized image of his
Fun Palace project, a site photograph is converted
deftly into a convincing impression of its potential
installation. To do so, Price drew directly on the
surface of the print using black and white ink, white
chalk, graphite and gouache.

traditional business of architectural representation or the creation of a house
style, his graphics function as mechanisms that exist simply to show how a
building or a structure will work.

Preferring drawings to words, Price makes his graphics 'speak' volumes.
Rich in spatial meaning, they are breathtakingly economical and deft in execu-
tion. Speed of visualization is essential because the drawings must respond to
his quickness of thought – the intricacies of a new design idea or the expan-
siveness of a rapid sketch made through the window of a speeding train simply
putting his remarkable drawing skill through its paces. Always exploiting the
mark-making potential of graphite or ink on different types of surface, his
drawings are usually diminutive in size and are often accompanied by handwrit-
ten annotation. Endlessly inventive, these no-nonsense drawings display the
techniques for which he is famous. Indeed, one such drawing is owned by
David Hockney.

When not existing in pure line his drawings can be developed in tone –
often quickly applied from the side of a piece of graphite stick. Further tonal
elaboration will enlist other media. For instance, Price loves to work on
materials such as site photographs, finding them a useful discipline. One much
published example of his unique imagery, the night perspective of the Fun
Palace project – a drawing Price considers to be rather too laboured for his
taste – uses black and white ink, white chalk, graphite and gouache directly
applied to the face of a glossy site print. Another technique from the same
project frames a negative print of an 'aerial' photograph of the model to give a

strong impression of the scheme as if seen from a helicopter. Further techniques simply incorporate a collage of photographic or photo-copied elements into a drawing or use photographs as underlays for tracing-paper delineations that often extend the lines beyond the limit of the photograph 'to make a point'. One such technique used on the 206 Berlin project – a design for an ideal office enviroment worked in conjunc-tion with students at the Technische Universität and the Hochschule der Künste in Berlin – begins with a Polaroid photograph of the site model. The instant print is then enlarged on a photocopier before being covered with tracing paper and receiving a rapid delineation in wax pencil to describe the form of the proposed intervention. Typical of Price's armoury of techniques is his use of a fragment of a photograph as the basis for a drawing. Perhaps this technique is best exemplified by his image describing a non-motorized self-relocating pier for the Ducklands project (page 154). Here, a section of a print selectively cut from a photograph of the model of the 'floating' walkway was glued down before being extended as a line drawing in black and red ink and graphite, applied in swift strokes.

BERLIN

206 BERLIN, photocopy
29.7 x 42cm (11³/₄ x 16¹/₂in)

An A4 photocopy print made from a Polaroid photograph of a model provides the basis for graphic adaptation by Price.

Price's extraordinary range of techniques is an exercise in an exuberant form of graphic opportunism. Any medium capable of making an interesting mark or creating a transformation can be enlisted. His basic range of drawing media include four Mont Blanc fountain pens – each nib specially ground to provide two line qualities and tempered in a flame to give it a long life. There is also his rubber stamp kit for titling drawings (he always uses red ink for

DUCK L'AND

overprinting), a Berol China marker, square graphite sticks, a child's four-hued coloured pencil, a Royal Sovereign 'Black Prince', a dual-coloured red and blue Rowney 'Victoria' pencil and a giant wax crayon, stratified in seven colours. Price will draw on anything, from paper scraps to the back of used dyeline paper. He also uses three small sketchbooks: one made by L. Cornelissen & Son containing plain white paper, another made by Price himself and filled with tracing paper, and a third filled with brown wrapping paper (a favourite drawing surface) specially bound for him by the Gilman Paper Co. in New York. Yet another portable drawing surface is a small 7.5 x 13cm (3 x 5in) card covered in a grid of purple. This has two functions: when over-printed with a rubber stamp it becomes his calling card; when left blank it acts as a readily accessible, pocket-sized drawing support – the non-reproducing quality of the purple lines allowing him to produce photocopied same-size or enlarged prints without the grid showing. Incidentally, the grid on his cards matches exactly the 5mm grid pattern on some of his shirts – the check on his shirt cuff also acts as a check on the scale of a developing drawing.

GREENBIRD, Moveable Aviary, Mixed Media Perspective
21 x 30cm (8¼ x 11¾in) (page 156)

This perspective of a design for a low-cost portable birdhouse was produced very quickly using Price's skills in combining drawing with found graphic elements. If we retrace the achievement of the Greenbird image, we uncover a series of different layers of media beginning with a base watercolour wash blending a blue to a grey. The perspective plane of the overhead deck was then quickly delineated in a fine-line blue marker together with its hint of structural space-frame – its mesh roof indicated with the side of a graphite stick and dots of blue marker. Next came the sky, its blue cut from a maga-zine advertisement which actually depicted the lighting tower that Price had found to be ideal for this structure. After being glued into position, back-ground trees were added using watercolour and blue pencil – the group in the far distance is suggested by graphite. Foreground shrubbery, pylon guys and track were then inserted in blue and brown marker respectively, together with dabs of white paint. This simply constructed image, carrying the visual power, ingenuity and invention that is associated with Price's work, was then completed with deft vertical strokes of China marker to indicate the deck supports. A final touch is the impression for the drawing's title, printed in red by means of Price's rubber stamp – a graphic gesture that acts now almost as his trademark.

DUCKLANDS PROJECT, Site from the River Elbe
Photocopy, 43 x 29.5cm (17 x 11⅝in)
(opposite, top)

This simply produced but powerful photocopy collage showing an aspect of the Ducklands site results from two laser prints from the same photographic original – one made in red and one made in black. The foreground silhouette was then trace-cut from the black print before being mounted and glued into the same position on the red print.

DUCKLANDS PROJECT, Self-Relocating Pier
Photocopy, 21 x 14.5cm (8¼ x 6in)
(opposite, below)

A selected portion of a photograph taken of a scale model of Price's design for a self-relocating pier becomes the starting point for a line drawing in black and red ink. The modification and extension of the camera's perception by that of his own is yet another dimension to Price's opportunistic, economical and highly efficient means of graphic communication.

GREENBIRD

GREENBIRD, MOVEABLE AVIARY (page 155)

After graduating from the Oxford School of Architecture in 1980, Giuliano Zampi joined D. Y. Davies, a multi-disciplinary design practice, where he worked for six years and was appointed as its computer manager. During this period he became highly skilled in computer-modelling designs, not only at the presentation stage of a project but also at its inception. In 1987, he moved to T2 Solutions, the company that produces Sonata software, where he worked in the

Giuliano Zampi

development section with its software author, Dr Jonathan Ingram. A year later, having acquired Ingram's personal Silicon Graphics machine, a system described by Zampi as the 'Rolls-Royce of computer modelling technology', he left to set up his own computer-modelling consultancy. Specializing in high-resolution graphics, Zampi's consultancy quickly took off, attracting commissions from leading architectural practices. His development of photorealistic computer images has also attracted graphic awards, and his work has been exhibited at London's Royal Academy as well as being widely published in the architectural press.

The most appreciable and magical advantage of the computer's powers in architectural drawing is its ability to generate highly accurate perspective views of the three-dimensional computer model. It is also capable of providing images as seen from specified viewing angles, in the context of the site and under different climatic conditions. These images may be used at any time during the design process. They may be employed initially to gain an impression of the mass and modelling of the proposed architecture or environment. Alternatively, they may be used later in the design process to examine links and sightlines through elements, or to explore the effects of colour, material and lighting.

By its very nature, however, the computer modelling of Zampi's high-resolution images can demand an exhaustive degree of detailed information, data that is not always readily available at the early stages of design. Therefore, in order to obtain this degree of input when working on commissioned projects, he will literally move into a practice, together with his machine. This itinerant approach allows Zampi to engage directly with the design team, become immersed in the spirit of the design, and, unlike the traditional perspective artist, visualize its form from a perceptual standpoint close to that of its designers. Consequently, Zampi's architectural background and his informed sensitivity toward his clients' individual architectural themes and associated styles have established his credibility among London's top architects. Furthermore, his computer models not only present a new and stunning realism in the evolution of architectural visualization, a quality Zampi hopes soon to animate, but they are also instantly recognizable as design products of the practice from which they emanate.

DEMONSTRATION IMAGE: CHANGING THE
VARIABLES
(1200 x 1000 pixels)

These two computer drawings exemplify the use of parametric objects in Zampi's work. Both represent the same view of a group of assembled parametric objects. To create an alternative image, however, their dimensions, colour and a number of elements have been altered. The whole ceiling structure is one object, as is the curved seating, and the window has variables for each section of its frame, mullions and glass. These variables can be manipulated or replaced time and time again.

CONTROL BUILDING, Cardiff Bay Barrage (opposite)

CONTROL BUILDING, Cardiff Bay Barrage, Cardiff Bay Development Corporation, Architects Alsop and Störmer
Computer-modelled Image (4000 x 4000 pixels)

Zampi was invited by Alsop and Störmer to produce visuals of the Control Building in order to communicate their design idea to the local authority client, and also to act as publicity material. After a series of detailed briefing sessions with the design team, Zampi began work by assembling a library of colours and materials on his computer – each scanned-in element describing the textures and surface properties that would be used in the construction of the building as a computer model. The colours and surfaces were tested exhaustively in small mock-up computer models using colours and lighting levels that responded to the designers' brief. In this case, colour and lighting effects were paramount but, as Zampi explains, different criteria can operate on different projects. While some architects are concerned with gathering purely technical assessments from a computer, others may wish to create a general massing of the building using realistic colour to judge the impact of their design on its setting.

The modelling process on Zampi's Sonata system is quite different from that of many others. His uses a highly sophisticated 'parametric library' of architectural objects and elements that he has developed himself. He claims that parametrics are the latest in intelligent systems and point the way for computers of the future.

The computer model image is constructed by placing parametric objects in the area of assembly. Dimensional questions, such as height, length and width, together with those concerning surface and colour, are answered as each object is assembled. Whole staircases, structural systems and windows of all types and configurations can be introduced and positioned in this way, all complete with their relevant and 'intelligently' integrated details. Consequently, the developing computer model can be interrogated and, as it resides as a mini database, be easily modified at will. Once the computer model is complete, any number of different perspective views can be commanded, each with its scanned-in sky or urban backdrop inserted to provide a realistic photomontage effect.

This is where the power of Zampi's parametric library comes into its own. For instance, rather than accessing each individual element in the model, Zampi, using a palette of 1.6 million hues, can now change completely the colours or the dimensions of a whole section of the model. The final image is printed on an inkjet colour printer or output as digitally produced transparencies, from which standard photographic prints can be made.